Victorian & Edwardian
Suffolk

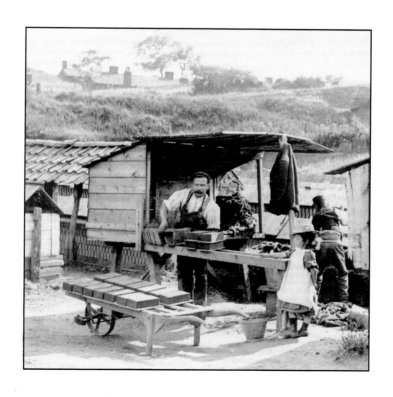

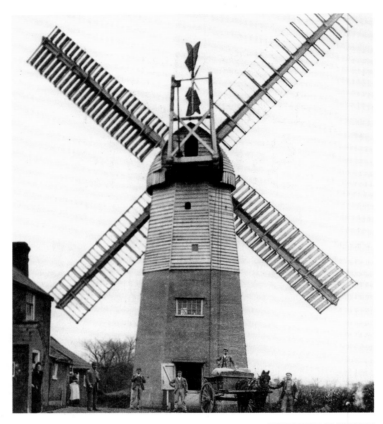

WALTON, IPSWICH

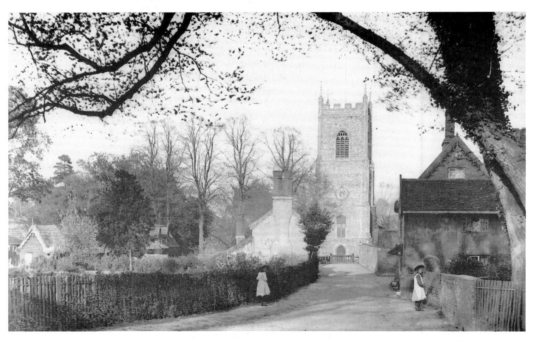

LOWER UFFORD

Victorian &
Edwardian
Suffolk

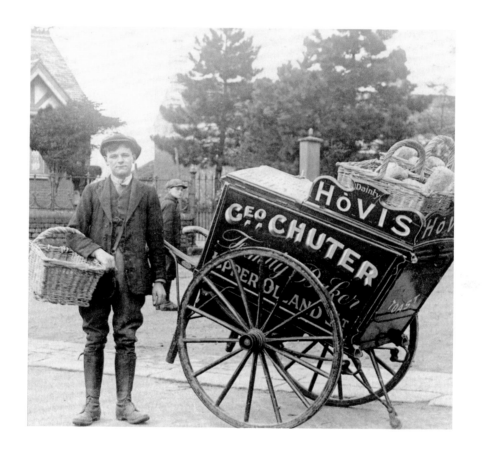

Humphrey Phelps

AMBERLEY

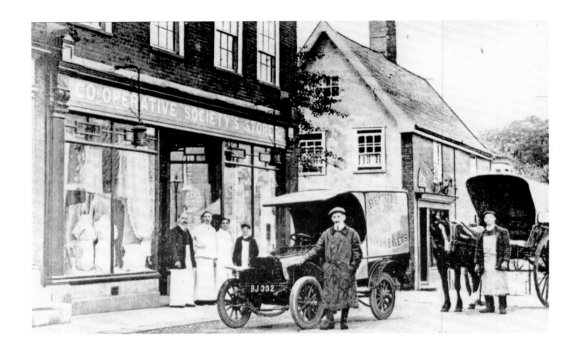

First published 1993 under the title *Suffolk of 100 Years Ago*
This revised edition first published 2008

Amberley Publishing
Cirencester Road, Chalford,
Stroud, Gloucestershire, GL6 8PE

British Library Cataloguing in Publication Data.
A catalogue record for this book is available from the British Library.

ISBN 978-1-84868-029-6

Typesetting and origination by Amberley Publishing
Printed in Great Britain by Amberley Publishing

This book, *Victorian & Edwardian Suffolk*, is an attempt, in both words and photographs, to depict Suffolk as it was between 1880 and 1910. In making my choice of text and photographs I have tried to present the life and work of the ordinary people of Suffolk as well as the county itself; in short, the Suffolk of those days. They were good days for some, bad days for others but that could probably be said of any age. On the whole the photographs give the impression of a more settled life than some of the text; the latter includes events which were by no means ordinary but which must have had an effect upon the ordinary people of those years.

As Suffolk was predominantly and pre-eminently an agricultural county I make no excuse for the inclusion of a large amount of material concerning rural matters. *A Farmer's Year*, written in 1898, and *Rural England*, published four years later, have been invaluable sources and I have used many extracts from these books. Both were written by Henry Rider Haggard who farmed near Bungay, and whose fame as a novelist should not distract from his well-informed comments on rural life. Another book from which I have included several extracts is *The Reminiscences of Country Life* by James Cornish whose father was Vicar of Debenham from 1860 to 1883.

The many books by George Ewart Evans have also been of inestimable help in compiling this book. Mr Evans who concentrated upon the life and work of ordinary people, was a pioneer of oral history and by his diligent work managed to capture a wealth of material that otherwise would have been lost forever, some of it being the very stuff of life that had been disregarded before he showed its rare value. It is all the more valuable because it came straight from the mouths of men. First-hand evidence of the days they had seen, many of them, fortunately for this book, between 1880 and 1910. As he has explained, he did it just in time, while the men who remembered those days were still alive and just at the time when their way of life was vanishing or had already vanished. Earlier, they would not have been disposed to talk, and while horses were still the power on the land the horsemen would not have divulged the secrets of horse lore. The diary of Philip Thompson, written in his teens, provides some interesting sidelights on Ipswich and I am indebted to his daughter-in-law, Mrs E. Thompson, for bringing it to my attention and for allowing me to include extracts of my choosing. Trevor Westgate and Peter Cherry have also been generous by allowing me to use extracts from *The Roaring Boys of Suffolk* which provide some of the all too few accounts of sea-faring life. Newspapers have been another useful source, they too give some

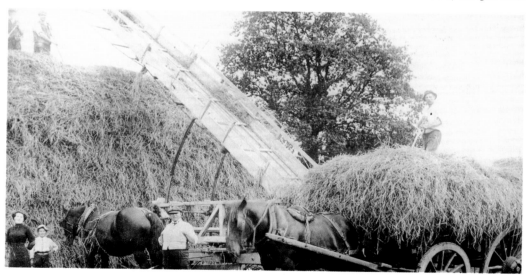

CRANLEY GREEN

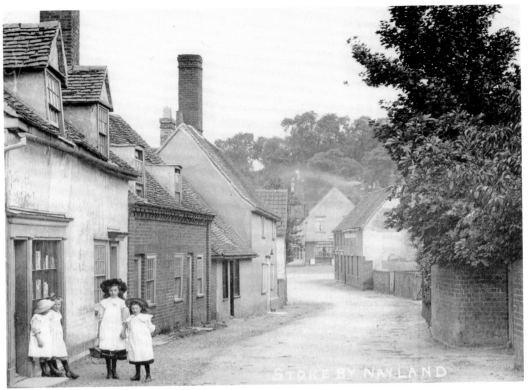

STOKE BY NAYLAND

interesting sidelights and like Philip Thompson's diary show that Suffolk was not always the tranquil scene that so many of the photographs present.

To my regret the domestic scene is not well represented, probably because the Suffolk housewife was far too busy to record her life, even had she the ability to do so and thought it worth doing. Likewise, the photographers probably did not think cottage interiors of sufficient interest, although evidently they were keenly interested in villages, however small and remote those villages were. Surprisingly it was hard to find suitable accounts of industrial life; Suffolk seems to lack a recorder of life in a factory as Wiltshire had in Alfred Williams.

The same is true of the workhouses, which cast a shadow over the lives of so many; the inmates did not write memoirs, while from official records we can assume that those forbidding institutions were presented in a more charitable light than the charity they dispensed. However, I cannot refrain from mentioning an incident recorded in the minutes of 1910 from Wickham Market Workhouse: a local widower, wishing to remarry, asked the guardians if he could pick a suitable wife from among the women in the workhouse. Eleven women were assembled, most with illegitimate children and he chose one with two children.

The generosity of several people has allowed me to include a good array of photographs which I believe give a reasonably comprehensive view of the county. As with the text they do not cover every aspect—that would be an impossible task—but they cover enough to illustrate both the spirit and the Suffolk scene of one hundred years ago. At first I thought it would be very difficult to collect a sufficient number but that was not the case and I finished not with a dearth but with a surplus of photographs. Many of them are from postcards and I am amazed how they have survived for a hundred years. Occasionally the inscriptions on the back were as interesting or intriguing as the photograph itself.

Compiling this book has been a pleasure rather than a task and what task it has been has been a labour of love. I am not a native of Suffolk but I fell in love with Suffolk many years ago and despite the changes that have occurred during the last forty years my love for Suffolk remains unchanged.

INTRODUCTION

When William Cobbett visited Suffolk in 1830 he found the country around Ipswich 'so well cultivated; the land in such a beautiful state, the farmhouses all white, and so much alike; the barns, and everything about the homesteads so snug; the stocks of turnips so abundant everywhere; the sheep and cattle in such fine order; the wheat all drilled; the ploughmen so expert; the furrows, if a quarter of a mile long, as straight as a line, and laid as truly as if with a level; in short, here is everything to delight the eye, and to make the people proud of their country; and this is the case throughout the whole of this county.'

Suffolk is a county of contrasting soils. Along its coasts it has sandy heaths constantly being eroded by the sea; in the northwest heaths eroded by the wind; to the south the Stour Valley; and in the north-east the Waveney Valley. And the middle region, known as High Suffolk, which was once a vast forest of oak where fertile but retentive clay had to be tamed and drained to become productive agricultural land. Both its soil and climate made Suffolk ideal for arable farming. But not the specialized arable farming we know today; sheep were a significant part of its farming. Dairying was extensive in some districts and the Suffolk Dun produced milk which was made into butter and sent in large quantities to the London markets.

The county produced three splendid breeds of livestock. The Suffolk Horse to till the land, the black-face sheep which fed upon the land and fed the land as well. By crossing, the Suffolk Dun, 'the little mongrel breed', as the Suffolk-born Arthur Young called it, eventually merged with the Norfolk to become the dual-purpose Red Poll which was admirably suited to Suffolk farming. The standard of Suffolk husbandry was high, and it was farming that shaped the pattern of the county and its villages and moulded the character of most of its people. As late as 1900, only five towns had over five thousand inhabitants whose combined population amounted to no more than thirty-five per cent of the county's total population.

The economy of Suffolk was dependent upon agriculture and to a lesser extent upon fishing. Over forty thousand people were engaged in farming and about three thousand in fishing. Most of its industry was dependent upon farming; two thousand men were employed in the blacksmith trade alone. There were the wheelwrights, the men

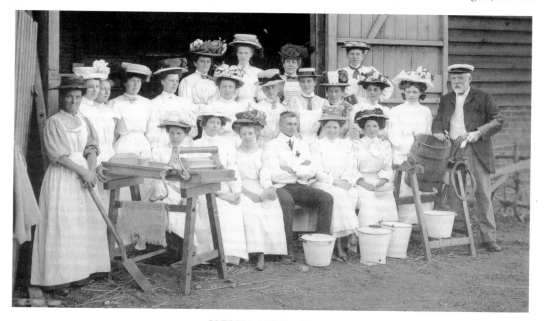

BUTTER-MAKING COMPETITION AT WICKHAM MARKET

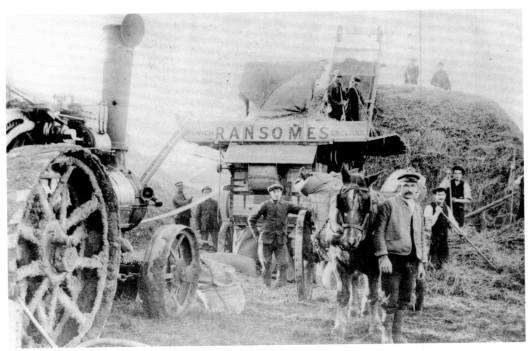

STEAM THRESHING AT BARKING

who made wagons as well as wheels, a thousand altogether; the harness makers, hurdle makers and agricultural implement manufacturers. In all there were thirty-five implement manufacturing businesses. The products of the three largest—Ransomes of Ipswich who made the best ploughs, Garrett's of Leiston who made traction engines and threshing machines, and Smyth's of Peasenhall who made the best corn drills—were famed beyond the boundaries of Suffolk and the shores of Britain.

Windmills were a feature of the Suffolk landscape which had impressed Cobbett, 'the most beautiful of the kind I ever beheld. . . and their twirling altogether added greatly to the beauty of the scene'. Most parishes had at least one windmill and some had a watermill too; in 1900 there were still almost four hundred windmills in the county, about three hundred and fifty cornmillers and a couple of dozen millwrights. The lighter lands were ideal for growing malting barley and there were one hundred and thirty maltsters, each employing several people, and about fifty breweries. The basket makers supplied the home, farm, trades and more distant markets; coopers made barrels for the brewers, the fishing trade and the farm. Life and work were dovetailed. The local bootmaker made the stiff, heavy hob-nailed boots and the tailor the corduroys which the farmworkers wore. The horses were bred on the farm and fed off the farm—there was also an extensive trade in hay to the towns, in the days of horse transport hay was then like petrol and oil are today. The miller ground the corn for the farmer and the village baker baked the bread although many families baked their own bread. The miller also ground the corn gleaned by farmworkers' families—gleaning was important to many families, who without it could experience real hunger. It would have been a self-sufficient community had everyone had sufficient.

By the middle of the nineteenth century, the enclosure of Suffolk, begun in the Middle Ages, was completed and the period of High Farming commenced. Fields were drained, new methods introduced; attention to detail and the four-course rotation became the practice. Farms became larger—there were complaints about turning small farms into fifty-acre fields. However, although the system of husbandry was admirable it was marred by a grievous black spot: the wages, housing and general conditions for the men who made it possible were deplorable.

Some workers sought to improve their lot. With support from the newly formed National Agricultural Labourers' Union they attempted to get a wage increase, which met with stiff opposition from farmers. In the spring of 1874 farmers locked out all union members but before harvest the workers had to capitulate. In that same year troops

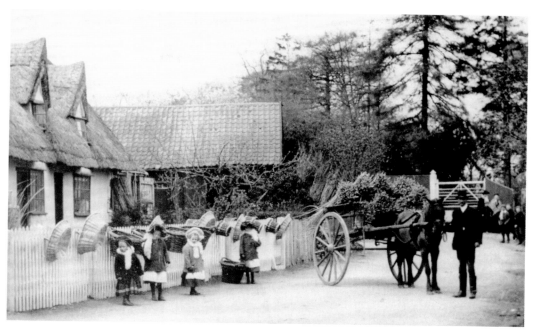

THE BASKET MAKER'S SHOP AT GRUNDISBURGH

were called to a crowd at Brandon bearing a banner proclaiming 'Bread or Blood in Brandon this day'. Around Halesworth and some other districts shops and barns were raided, farmers and magistrates threatened.

Some landowners were more enlightened. In 1839 Mr Gurden of Assington had started a scheme to improve the lot of farmworkers; he rented twenty of them one hundred acres to run co-operatively and lent them both stock and capital. His experiment was a success, the loan repaid and the scheme was extended in 1852. The provision of allotments, started in 1820, was also opposed by farmers but by the 1880s there were over fifteen thousand allotments of under one acre and about seven hundred of more than an acre.

The period covered by this book sees the collapse of High Farming and the start of an agricultural depression which was to last until the First World War. Following a number of years of bad weather, 1879 was disastrous. It was a year of heavy and continuous rain. Cattle sank up to their knees in pasture and grazing was ruined. Sheep died by the thousands. Haymaking was late and the hay crop was inferior. Corn rotted in the fields and that which was harvested was of very poor quality. Scarcity did not help its price because vast amounts of grain were pouring in from America. And that year the first shipment of refrigerated beef arrived from Australia, soon to be followed by cheap beef and lamb from Argentina and New Zealand.

Land values and rent slumped, thousands of workers lost their jobs; arable fields were unploughed, ditches and hedges neglected; houses, cottages and barns became dilapidated. Farmers who had once owned their own holdings went on the parish dole—a pound of flour and 3d a day. The price of wheat fell from 56/9d a quarter in 1877 to 22/10d in 1894; by 1900 the acreage under corn in Suffolk had been halved. Some farmers turned from corn to stock but were faced by the fierce competition of cheap imported meat. In 1898, Henry Rider Haggard wrote:

Notwithstanding the care, knowledge, and intelligence which are put into the working of the land, under present conditions it can scarcely be made to pay. The machinery works, the mill goes round; the labourers, those who are left of them, earn their wage such as it is, and the beast his provender; the goodman rises early and rests late, taking thought for the day and the morrow, but when at Michaelmas he balances his books there is no return, and lo! The bailiff's glaring through the gates . . . In our parts the ancient industry of agriculture is nearly moribund, and if the land, or the poorer and therefore the more considerable portion of it, is farmed fairly, it is in many instances being worked at a loss, or at any rate without a living profit . . . The small men only too often keep up the game till beggary overtakes them, when they adjourn to the workhouse . . . The

larger farmers . . . at last take refuge in a cottage, or, if they are fortunate, find a position as a steward upon some estate. The landlords . . . unless they have private means to draw on . . . sink and sink until they vanish beneath the surface of the great sea of English society.

And in 1901 he said:

I can only describe the conditions prevailing in rural Suffolk at the present time as disastrous.

The poor lived in dread of the workhouse, a dread that would not disappear until well into the twentieth century. The 1834 Poor Law Amendment Act had amalgamated parishes into unions (each with a workhouse), and almost entirely abolished outdoor relief. Suffolk had seventeen Union Workhouses. Persons unable to support themselves were accepted into the workhouse after being subjected to 'the workhouse test'. On entering the workhouse families were split up, husbands from wives, parents from children. Comfort was minimal at best, diet was sparse and discipline was harsh. The workhouse was made grim deliberately in order to encourage its inhabitants to go outside and find work, with the object of discouraging pauperism. The attitude was that if people were obliged to look for employment there was employment—an attitude which has not entirely disappeared in our day, with the injunction to the unemployed to 'get on your bike'. The system did little to relieve the poor, it merely rejected them. Those who experienced the harshness of the workhouse were not able to record life literally from the inside. Rider Haggard saw men from the workhouse in his local church:

They could not read and I doubt if they understood much of what was passing, but I observed consideration in their eyes. Of what? Of the terror and the marvel of existence, perhaps, and of that good God whereof the parson is talking in those long unmeaning words. God? They knew more of the devil and all his works; ill paid labour, poverty, pain, and the infinite, unrecorded tragedies of humble lives. God? They have never found Him. He must live beyond the workhouse wall, out there in the graveyard, in the waterlogged holes where very shortly . . .

It was not until 1876 that legislation established that all children should receive education and imposed further restrictions upon the employment of children. Four years later attendance at school was made compulsory for children up to ten years of age. But many Suffolk school log books referred to absenteeism due to such things

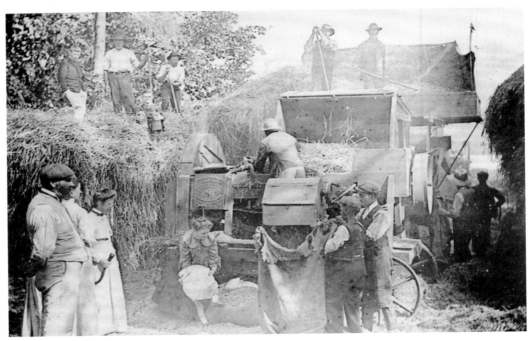

EARL STONHAM

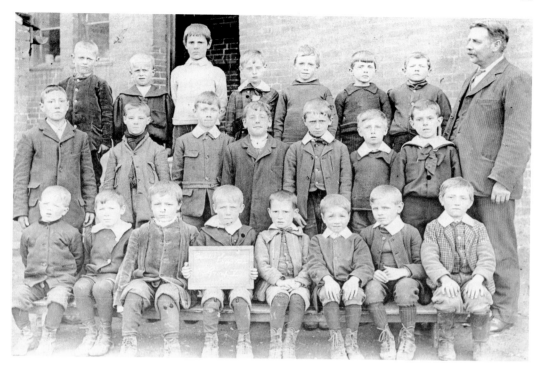

FRAMLINGHAM

as 'bird-keeping' (bird-scaring) or 'working in the fields'. Bird-scaring, one man remembered 'was very lonely work, and I was often perished with cold before the end of the day. If I stopped making a noise, someone from the farm would soon be along'. Harvest took precedence over everything and the summer holidays were known as 'harvest holidays'. If harvest was early the holidays were brought forward and extended if harvest was late. Bawdsey School was frequently closed because of epidemics; on other occasions, 'No fires, no fuel, school closed'. An entry in the log book of Hadleigh's National School records on 17 January 1881: 'Unable to get on With Writing on paper this Morning as ink became frozen as soon as poured.' During the next two days the worst snowstorm of the century occurred.

Field work was a constant cause of absenteeism from school and attendance did not improve greatly when schooling became free in 1891. The parents of large families—and there were many large families in those days—wanted their children to earn as much money as possible in order to pay for their keep, so they sent them into the fields instead of sending them to school. A farmworker's wages were about ten shillings a week if he worked a full week, but many workers were 'daymen' (hired by the day) and if the weather was unsuitable for field work they were sent home, thus losing a day's pay. Child labour was cheap and at peak periods plenty of labour was needed so farmers were glad to employ children for seasonal work. Gathering stones from the fields was another job at which children were employed.

At this period there was a considerable migration of labour. Some Suffolk landworkers would go harvesting in Essex, where the harvest was slightly earlier, and then return for the Suffolk harvest. While Lincolnshire men would come to Suffolk and then return to Lincolnshire where the harvest was later. After harvest many Suffolk workers went and worked in the maltings at Burton-on-Trent and returned in time for hoeing and haysel in Suffolk. Others, mainly those near the coast, went fishing in the autumn and early winter months—these men being known as 'half-breed fishermen'. During the herring season large numbers of Scottish girls invaded Suffolk—principally Lowestoft and Southwold—to gut, salt and pack the herrings for export.

The railways gave a great boost to the fishing industry because the catches could then be quickly transported to other parts of the country. Eventually docks were enlarged, new docks and harbours and fish markets

constructed. At Lowestoft the number of local drifters increased from eighty in 1841 to almost four hundred in 1900; the number of trawlers from eight in 1863 to almost three hundred by the 1880s. And the fishing industry created in turn more ship, boat and barge builders, rope and sail makers, barrel making, fish curing . . . Scottish fishing boats as well as Scottish girls came to the ports.

The railways also brought more industry, trade and, to the seaside resorts more visitors. Nevertheless the railways were also a factor which encouraged people to leave Suffolk. By 1891 over twenty-three thousand Suffolk-born people were living in the north of England and over fifty thousand in London.

At the end of the seventeenth century Celia Fiennes remarked that Woodbridge 'has a great meeting for the Dessenters' (sic) and during the first half of the nineteenth century Nonconformity increased rapidly and by the end of the century had some three hundred and sixty Meeting Places. The Church of England however, still attracted more worshippers than all the denominations combined. The daughter of the vicar of the small parish of Barnardiston recalled that 1898 was a time of large families and full churches and that her father on his annual stipend of £160 kept a maid,

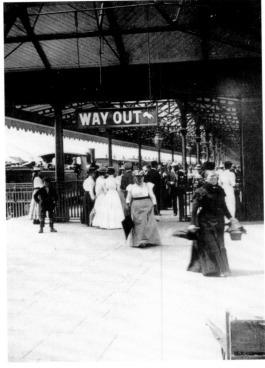

FELIXSTOWE TOWN STATION

a liveried manservant and a horse and carriage. She also said there was more merriment in those days.

Could this have been true, with all the hardship, poverty, poor housing, unemployment, the farming depression, the fear of the workhouse? Some of the photographs lend support to her statement. Probably there were both more misery and more enjoyment. The rural people, as one writer has observed, lived without ambition but not without content. The village was an organic whole, a close-knit community which furnished its own needs and amusements; the frolics, outings, flower shows and so forth. And tribute must be paid to the men who served the

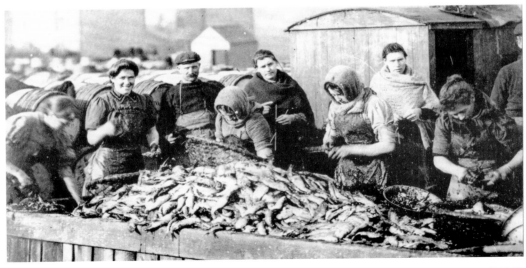

LOWESTOFT

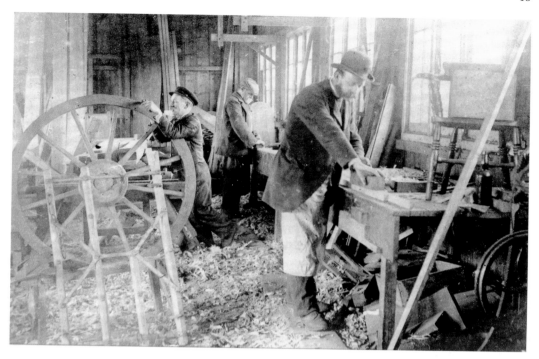

WHEELWRIGHTS AT HOLLESLEY

land instead of being servants of the machine which has drastically altered much of the Suffolk landscape of today. The horseman who held pride of place on the farm and in the community, who took great pride in his horses and his work. And also in himself; many horsemen had a good suit of clothes made by the local tailor at a cost of five guineas which represented his wages for ten weeks. The milk men and the shepherds who, like the horsemen, worked three hundred and sixty-five days a year. The hedger, ditcher, thatcher and all the other farmworkers. To quote Adrian Bell: 'Now I see the rare rhythms of their work, building a round stack broadening from the base like a peg top. What instinct, what an eye for form they had . . . the quiet of their strenuous farming days . . . the rhythm of the tread of a dozen horses in plough trace or shafts, which governed the rhythm of the farm . . .'

Adrian Bell farmed in Suffolk, in the 1920s, and the work he described in his first book, *Corduroy*, hardly differed from that of the nineteenth century. Thomas Hardy and Richard Jefferies had never experienced the rhythms as Adrian Bell had. Hardy had only a superficial idea of farmwork and Jefferies had never done any farmwork although he was the son of a small farmer. Both of these writers and others correctly stated the low wages and bad housing of farmworkers but through ignorance ascribed the wretched conditions to the work itself. Jefferies wrote of the farmworker that 'his life and work were animal'. Unlike Adrian Bell, these writers were merely observers who saw the long walk behind the plough, the labour of wielding scythe or billhook, the bent backs hoeing, the pitching of sheaf after sheaf, but were ignorant of these rhythms. Which, as Adrian Bell knew, 'gave a sort of jollity to the job of using all the tools of farming, so that men could talk and joke as they did it'.

To these men—and women and children—to all those craftsmen: the blacksmiths, wheelwrights, builders, fishermen, corn millers, mill wrights and many others, we owe the scenes in the following photographs. They and those before them left us a rich legacy, the Suffolk landscape. The pity is that so much of that legacy has now been thoughtlessly and needlessly squandered.

The photographs show how so much has changed since they were taken. What is even more remarkable is that so much has changed, not in a hundred years, but in the last fifty years. Apart from the clothes many of the photographs could have been taken in the 1930s or even the 1940s. Fifty years ago the muscle of man and horse was still the major source of power on the farm; corn was still being harvested with a reaping machine, sheafs were in stook in fields before being loaded on to wagons and built into stacks. Gangs of men were still working

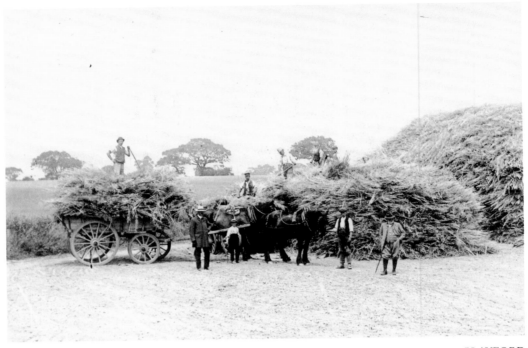

PLAYFORD

in the fields as in these photographs. Now we have a landscape without figures; Cobbett, seeing the effect of enclosures, spoke of landless labourers, now we have labourless land. He also spoke of absentee landlords, now Suffolk has absentee farmers as well. Villages only forty years ago were still populated by farmworkers and fishermen as they were a hundred years ago. During the last war an American serviceman could write: 'The Suffolk hedgerows are thick with hawthorn and wild roses, with crab apples and holly and wild plums, so that in the spring the fields are bounded with walls of blossoms and the lanes are fragrant with their scent.'

Now they have vanished; the hedges, the small farms, the land workers, the Suffolk Horses, the Red Polls, the varied hand tools of farming; and a way of life that had lasted for generations. All gone within not a hundred but the last forty or fifty years. The year 1940 now seems as remote as 1890. But the workhouses and the grinding poverty have also gone and for this at least we should be thankful.

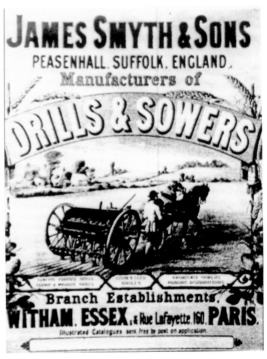

JAMES SMYTH & SONS, PEASENHALL

Victorian
& Edwardian
Suffolk

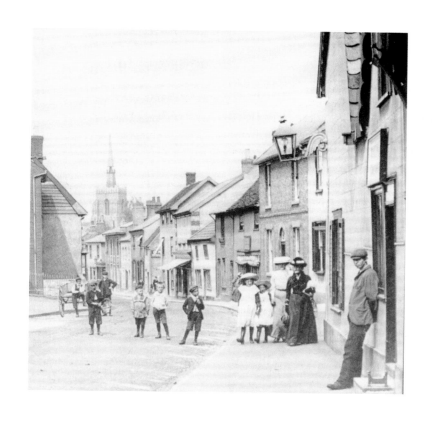

RANSOMES "SMALL HOLDINGS" CULTIVATOR

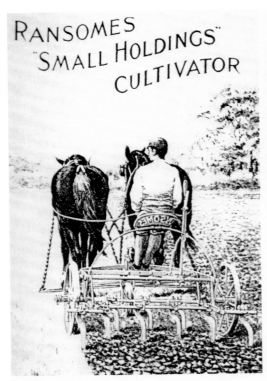

RANSOMES, SIMS & JEFFERIES

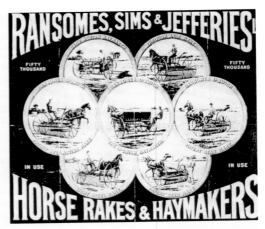

FIFTY THOUSAND

FIFTY THOUSAND

IN USE

IN USE

HORSE RAKES & HAYMAKERS

SUPREME IN MEADOW AND HARVEST FIELD.

The Most Popular Ploughs in Kent
MANUFACTURED BY
RANSOMES, SIMS & JEFFERIES, LTD

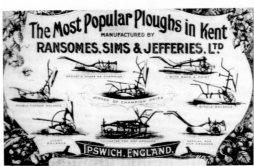

IPSWICH. ENGLAND.

RANSOMES' NEW STEEL CHILL PLOUGHS

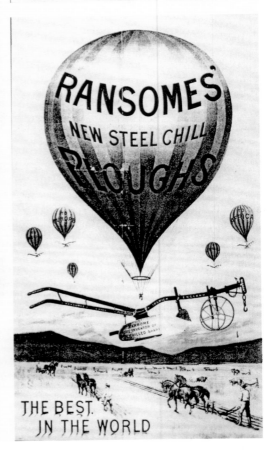

THE BEST IN THE WORLD

RANSOMES SWATH TURNER
(JARMAIN'S PATENT)
THE NEWEST AND BEST IMPLEMENT FOR MAKING HAY

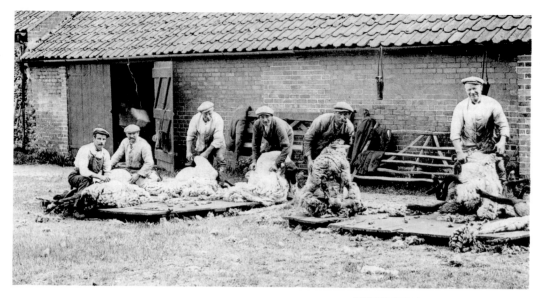

SHEEP SHEARING AT FOXHALL

THE BLAXHALL COMPANY OF SHEEP SHEARERS

In this parish the sheep-shearing used to be one of the big occasions of the year. The clipping was done by a body of men known as the Blaxhall Company of Sheep Shearers. At the turn of the century, and earlier, it was no use for a farmer to try to hand-shear his own flock of sheep: it would take too long. Moreover the shearing came at that time of the year when most of the workers would be busy at the *haysel* or hay harvest. Therefore it was the custom for companies of men to be formed: these went round to each farm specially to shear the sheep. The Blaxhall Company goes back further than local memory or written records, and it probably has its origin in the sixteenth or seventeenth century or even earlier.

The men who made up the company fifty years ago were not all-the-year-round employees of any one farmer; they were independent men working on their own account at such jobs as hedging and ditching on piecework; bark-peeling or any other seasonal occupation connected with agriculture. During the six or seven weeks of the sheep-shearing season any one of the company could earn as much as the average farmworker would during six months of continuous work. His was a skilled job, and the expert sheep-clipper who could take off an entire fleece without once snipping and injuring the sheep was well thought of and of great use in the old farming community.

Before the clipping started, the Blaxhall Company elected a captain to command it; the captain in his turn chose a lieutenant who would write the letters and would be a kind of clerk dealing with the business side of the company. The procedure, it may be noted, is very much like that of the harvest company and the lord and lady who organized the harvest.

On the Sunday night before the shearing season started, the company gathered at the village inn, appropriately called The Ship (Sheep) Inn. The landlord used to reserve a special room for them, and help them in a general way—by ordering a supply of whetstones which they used to sharpen their shears, and by cashing their cheques for them when they were paid by the farmers. To the Ship Inn would be summoned the shepherds of all the flocks the company proposed to shear during the ensuing week. The captain would arrange with each shepherd the day that would suit him best for shearing; and the shepherd would undertake to have his flock ready on the appointed day. This was called 'allotting the sheep'. Having made their arrangements for the week the company would disperse. Next morning at six o'clock they would assemble at the first farm on their list.

Their first job was to prepare the shearing platform. For this they lifted the two big barn-doors off their hinges and laid them on bricks to form a raised table. The shepherd would have his flock ready penned for them. At this time of year there are frequently heavy dews; and if the flock was left out all night the clippers' work would

be delayed until the fleeces had dried out. Therefore if the shepherd was at all able he placed his flock under cover—either in barn or cow-byre—on the night before the shearing, thus making sure that there would be no hold-up in the morning.

There were eight or nine men in the Blaxhall company when it was at full strength; and these could clip the wool off a whole flock during one day. A sheep-shearer using the handshears could clip nearly two score of sheep during the day; he would take from eighteen to twenty minutes for each sheep, depending on the state of the fleece. The length of the working day would be from twelve to fourteen hours. Every three sheep clipped—so was the Blaxhall custom—the shearer rested for a *horn* of beer. Every five sheep he had what was known as a *pull-up and sharp*—beer with a drop of gin and time to sharpen his shears with the whetstone. If the wool had not *come up* properly he would have to sharpen more often. The pay, about fifty years ago, was five shillings for every score of sheep sheared: when one considers that an ordinary farmworker here was at that time getting not much more than ten shillings a week, this was good pay. But it was gruelling work, especially for the first few days, before the muscles of the wrist had become hardened to the constant gripping and working of the shears. After the first day, each man's wrist would be swollen up and painful; but gradually this wore off as the week went on.

George Ewart Evans

TRAVELLERS

Another class of men who had to travel far were the ostlers at the Railway Inns of smaller towns such as Needham Market and Framlingham, and the driver from The Lion, the best of the ten inns which stood in Debenham Street. Commercial travellers needed their sevices to reach outlying villages, and there were besides occasional calls on them from people like ourselves who had no horse or pony.

On the long journeys there was plenty of time for conversation. Once, when driving from the station, I gained much information about poaching. We passed stubble fields carefully sprinkled with thorn bushes to prevent the netting of partridges at night. 'Them bushes ain't a mite of use,' said the driver. 'A good net would easily go over them.' 'What are the best sort?' I asked. 'Strong stakes,' he replied, 'or little loose ones that roll up in the net.' So I asked for more information and got the following. 'One winter when I was out of work for fourteen weeks

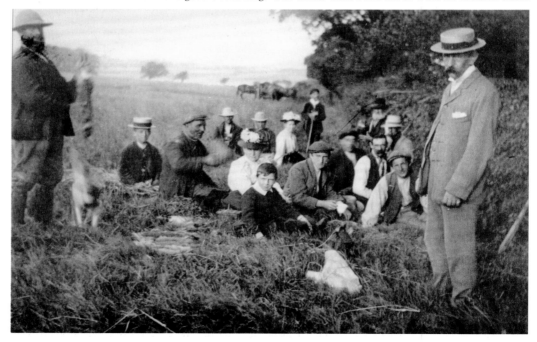

HARVEST AUCTION OF RABBITS AT WALDRINGFIELD

SNAPE

I took up with it. My pal was a dead hand at the game. Lubbiger we called him. I do not rightly know his name. One day we were out with two good, long dawgs and had got two hares. Then they runned another. I was just picking it up when a keeper jumped out of a hedge and came for us. Lubbiger he runned up and said, "Give me the hare", and away we went alongside the ditch, he behind me. Just as the keeper drew up to him he swung that hare round, caught the keeper on the side of the head and knocked him into the ditch. "Now", he said, "run hard", and blessed if he did not keep ahead of me though he had two hares in his pockets and one in his hand. The dawgs went home at once.'

The poachers escaped, for Lubbiger insisted that as soon as the hares were hidden they should go at once to the public house to establish an alibi. As he expected, the keeper soon looked in, and though suspicious, could hardly believe that the men he had chased would have the impudence to go so quickly to the public house.

Other drivers were more taciturn, yet cultivated the art of epigrammatic sayings; John Andrews, of The Lion, for example. 'What sort of a man has that farm now, Andrews?' 'Wonderful fond of gin and beer, Sir.' Once, when alluding to a very lazy individual, I said, 'He never seems to take his hands out of his pockets.' 'No, Sir, 'cept when he puts 'em into other people's,' said Andrews. Question: 'How is Caleb Kenton getting on now?' Answer: 'Nothing wasted in that house; what he don't drink the missus will.' Andrews was 'no scholar', could neither read nor write, and that, he said, was why he never could take a higher place, even as driver for a tradesman, because he could not read addresses on parcels. That simple statement of his brought home to me what a barrier not being able to read was to improvement in employment.

When one takes into consideration the length of our journeys, the roughness of the roads, and also the fact that few people made use of lights in their conveyances, it seems strange that accidents were not more frequent. When they did befall us it was generally because the horse tripped on a loose stone or fell when being sent too fast downhill. There were two ways of describing this mishap. If the owner were driving, he would say, 'The hoss hulled hisself down.' If he had hired it out or lent it to a friend, then a slight change of wording was employed, 'I tell yer he took and hulled that hoss down.' But, whichever way it might be, my own experience of many such events assured me that being pitched out of a two-wheeled trap by the falling of a horse is not pleasant. But that is not so startling as being run into by another driver. One night I had to hire something to take me home seven miles or thereabouts, and went to an inn at the village of Mendlesham to seek for a conveyance. 'Yes,' said the landlord, 'I will soon put the mare into the trap,' and we travelled comfortably, though rather slowly. He explained that the mare was rather tired as there had been a lot of 'sickness' about, and as I appeared puzzled, he added, 'I am a Doctor, leastways a "Veterinary".' It was a bright moonlight night, and he jogged along with a slack rein till just as we entered a piece of road where a very high hedge threw a dark shadow across, a tall dogcart and black horse suddenly appeared. A shout of 'Where are you a-comin' to?', a crash as the wheels locked, and the driver and I were catapulted into the road. Our traces had snapped; and the mare pelted away into the distance. Our assailant had got the better of us in the charge, for only one of his traces had broken. We managed to quiet his frightened horse. He was a young farmer living close by and was most apologetic, for he

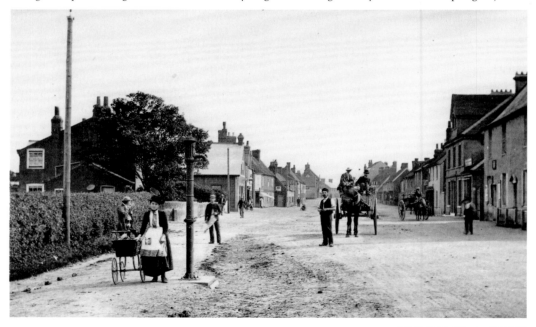

WALTON, FELIXSTOWE

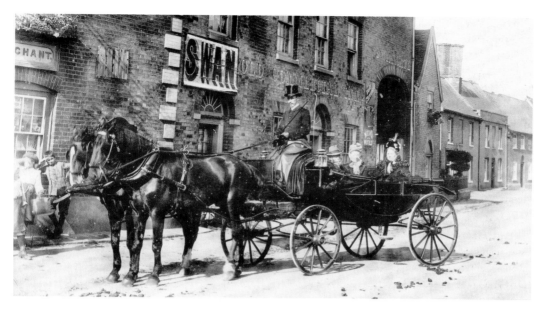

THE SWAN, WOOLPIT

had seen us clearly in the moonlight and did not guess that the shadow of the hedge made him invisible. He lit one of his lamps and accompanied us in search of the mare while his sister drove home. Fortunately we found our horse not far away, led her back to the cart, spliced the traces with string, and I reached home safely. But the mare was naturally very nervous, and every time she made something of a rush I expected that the patched traces would break and I should go over the dashboard again.

Most of our conveyances were dogcarts or tax carts, but one saw a few of those curious things irreverently called 'buggy hutches', where two wheels carried a covered vehicle like a large governess cart with a top to it, and the driver steered his horse through an open window. If the horse was sluggish a whip would be protruded and joggled up and down to urge him on. There was a glorified type in which the driver perched himself on a little seat high up in front of the vehicle and the ladies rode inside in safety and comfort.

James Cornish

STATE OF ROADS

The Revd R. Abbay, the Rector of Earl Soham, in a paper on local taxation, read before the Framlingham Farmers' Club in 1902, points out that the expenditure on the roads, which is very inadequately assisted by certain receipts from the Assigned Revenues and Agricultural Rates Grant, is one that is being felt far more heavily than any other in Suffolk. He says:

It has never been so great as it is at present, and, strange to say, the roads have never in recent times been so unsatisfactory a state as they were in 1901. The primary cause of this I believe is the doing away with the system of picking stones in the fields, due to the advance of education.

H. Rider Haggard

EARTHQUAKE

On Tuesday morning Essex and Suffolk, and to a small degree one or two neighbouring counties, were agitated by an earthquake which was undoubtedly the most serious disturbance of the kind that has been felt in this country during the present century. The shock was felt at twenty minutes past nine o'clock.

The Essex Chronicle, 25 April 1884

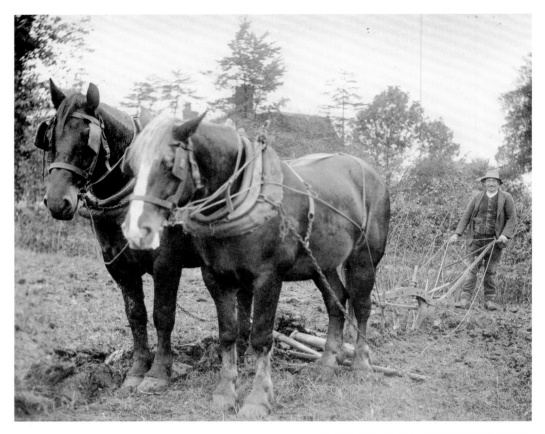

A RANSOMES, SIMS & JEFFERIES PLOUGH

HARNESS MAKER

The family of Rumsey, harness makers, had a workshop in the most picturesque part of the village, the crest of the hill up and down which the street runs. On the east stands the grand church, and the old houses on each side of the street have that pleasing form of construction in which the beams of the first floor project some feet. The great corner uprights are roughly carved, and often decorative plaster panels on cornices relieve the surface. The houses are not of the high quality which can be seen at Lavenham and some other places in Suffolk, but nevertheless are well worth studying.

How many thousands of acres of arable land depended on our shoeing smiths and our harness makers one cannot say. There were four smiths, for the cart horses must be shod frequently, while two harness makers with their journeymen and apprentices sufficed to keep up the supply of collars, traces, reins and all the rest of the tackle. The study of the many and curious brass ornaments with which a full set of 'trace harness' is decked is quite fascinating, and every good carter takes a pride in keeping them brightly polished. Harness making in all its forms, from the most finished work of the best London firms in hunting and racing saddles and bridles, to the humbler but even more antique craft of the men who work for cart horses, is one of the trades in which skilled hand labour still survives. Much patience and perseverance is needed to make the collar for a great cart horse. There is a curious sort of framework packed tightly with stuffing but shaped to the neck, so that there may never be a galled shoulder. Over this the leather is stitched and thread well rubbed in black wax. Men who work for animals need to be more scrupulously careful than those who work for human beings, because the animal cannot grumble if the shoe or collar pinches him.

James Cornish

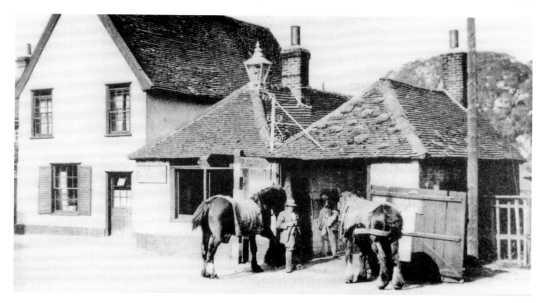

BLACKSMITH'S SHOP AT HADLEIGH

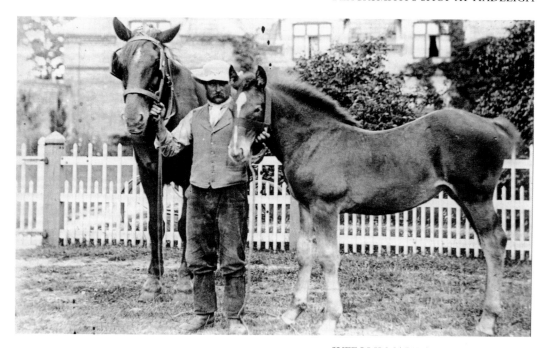

SUFFOLK MARE AND COLT, HOXNE

DEBENHAM

My father, Charles John Cornish, was Vicar of Debenham in Suffolk from 1860 to 1883. It was a large village of more than a thousand people, and as the villages for nearly eight miles round were much smaller, Debenham formed a centre of some importance. It lies in the middle of a great stretch of heavy clay land; in fact, for ten miles to the east and west, and for fifteen miles to the north and south, there is scarcely an acre of light land.

The clay, though somewhat sticky, produced wonderful crops of corn, beans and marigold. It may have been largely because the country was not very attractive for residents that over this great area the houses of country

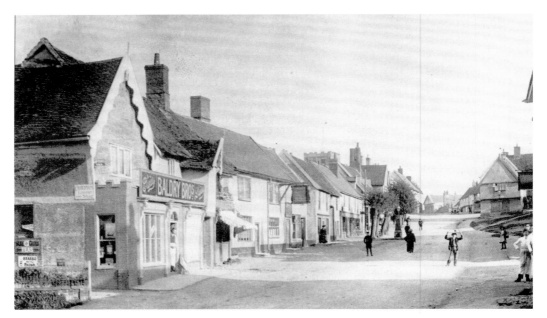

DEBENHAM

gentry were scarce. There were two or three great houses, the finest of them being Helmingham Hall, with its deer park and splendid old oaks and herd of red deer, but in almost all the villages the aristocracy consisted of the farmers and the parson. The intensity of cultivation undoubtedly diminished the picturesqueness of the country. One hardly ever saw an acre of land that was not cultivated; few woods, and no heaths or other wild country. The yield of the land was prodigious. In many parts of England only a small percentage of the acres in the parish produce much food, but at Debenham I think that some two acres of village green and less than that area of wayside strips were the only spaces that were not so utilized. And what prosperity there was for the farmers and landowners, though, alas, not for the workers on the land! The amount of efficient labour at the disposal of the farmers was practically unlimited. I well remember the gangs of children, boys and girls, at work in the fields, picking up stones to mend the roads, or dropping beans. For this a man would walk backwards with a heavy dibble in each hand, making a couple of holes at each pace, and the children would follow him, dropping a bean in each hole. The method by which the stones were utilized for mending the roads was very simple. When winter came they were taken from the stone heaps at the road side and spread where the ruts were deepest. There they remained loose until gradually worn in by the wheeled traffic.

The gang system led to so many dreadful results that it was prohibited by Act of Parliament. The farm labourers were paid a very small wage, and the housing conditions were deplorably bad.

With abundant cheap labour the standard of farming was remarkably high. The horses, the famous Suffolk punches, were excellent. Their fetlocks free from hair were well adapted for work on the heavy soil; their short legs, long, powerful bodies and high courage made them well qualified for full days of ploughing in a stiff soil. It was beautiful to see five or six pairs at work breaking the stubble on a fine autumn morning, their chestnut coats glistening in the sun.

The prices of wheat, barley and oats were so high that intensive cultivation was well justified. In 1860 the average price of wheat was 59s. a quarter, in 1864 50s. 4d. a quarter, in 1869 51s. 6d. a quarter. The prices of barley in the same three years were 37s., 35s. 8d., and 35s. 6d., prices which would make the Suffolk farmer of today most joyful. It was not a great district for oats, but beans were a profitable crop, though liable to leave the land somewhat too full of weeds. As very few sheep were kept, turnips were hardly grown, but beetroot for winter feeding of cattle were extensively cultivated. I can just remember the growing of flax for the 'Retiary' at the little town of Eye, and there can hardly be a more beautiful sight in a farming landscape than a field of blue flax.

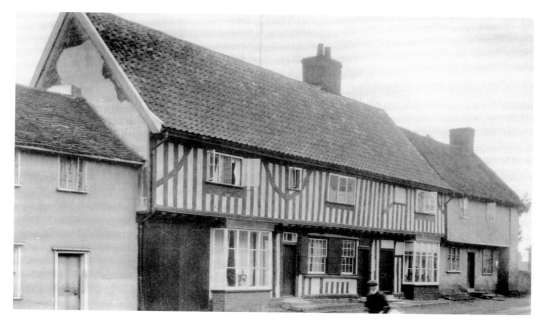

DEBENHAM

Then for another aspect of the matter, the progressive deterioration of the scenery. The land hunger was so acute that the big, straggling fences were grubbed up and the wide ditches tilled in and replaced by narrow, straight gulleys. Miles of wide grass verge beside the country roads were annexed by the adjacent landowners and a young quickset hedge planted beside the narrowed road. Isolated trees in the hedgerows, many of them good oaks, were ruthlessly felled, and one of the few nice woods in our district was entirely grubbed up and transformed into corn land. Another vast expenditure of labour and money was undertaken far and wide, the pipe draining of the land. Agricultural drain-pipes were laid from two-and-a-half to three feet below the surface and carried to the ditch down which the water flowed to the brooks which ran in the small valleys. No doubt this was a great gain to agriculture, for the well-drained land was less difficult to work and the crops did better in the drier soil, but there was one unfortunate result. The streams which had been sufficient to carry off the rainfall for the last thousand years were now required to deal with an immensely added flow of water when there was a long spell of wet weather. For this they had not sufficient capacity and so were liable to sudden floods. Since the Suffolk roads often ran close by some small stream, and the engineers had a trusting habit of letting a brook flow across a road into its channel on the opposite side, we now were faced with the problem of how to get to our railway station when the floods were out, or in winter how to cross in safety a piece of the road sheeted with ice.

I remember one day my brother Vaughan starting to drive to Needham Market station, nine miles off, then finding a torrent pouring across the road which the driver dared not negotiate, and being obliged to change his destination and race to catch the same train at Ipswich fourteen miles away.

James Cornish

A JOURNEY TO FELIXSTOWE IN 1902

I was only a boy when my mother took me to Felixstowe. There was about 13 of us in cart and 'Owd Pardgerum' (Mr Bloomfield) sat on shafts driving. Then when we were coming home we got as far as scrad in Ships (Sheeps) Drift and the owd hoss fell down dead and tipped us and all owd wimmen out.

Owd Mr Bloomfield he stood dumbfounded then said 'There! There! That have never a served me that ere trick afore.'

A. Aldis

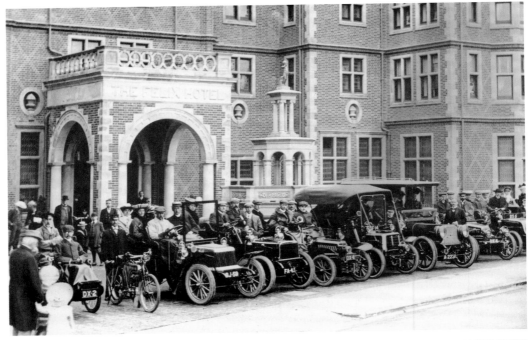

FELIXSTOWE

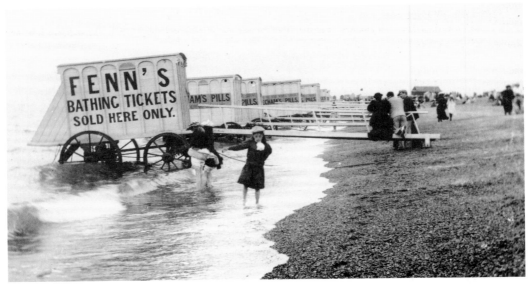

FELIXSTOWE BEACH

REGATTA DAY, ALDEBURGH

Regatta day, the day when the country people sowed their onion seed, regardless of weather conditions and of date! It was the one day in the year when stalls and temporary booths were allowed on the top of the beach. The country folk streamed in by train and cart, old Noah Crane from Henry's former parish came with his little hand organ, and sat on the ground grinding out his tunes, hoping quite as much for a word with his late vicar as he did for a coin from him in the cap beside him on the ground.

A few people watched the racing, but most of them were taken up with the stalls that sold bright pink peppermint rock; or they had their fortunes told by little green love-birds, who hopped from a cage on to a tray filled with paper slips, and picking one up, presented it in their beaks, after a coin had been placed on the tray. The camera obscura did a brisk trade, although the best of the fun was at the fair on the old Fort Green.

All the usual delights were there, steam horses, cocoanut shies and water squirts. Also a truly horrible 'pleasure' called the 'Ocean Wave', calculated to make the most hardened inside turn the wrong way up! It is true some of the beachmen sat in it with a look of real satisfaction, and said 'it was most as good as being at sea in a heavy swell', but when mere landsmen tried it there were some regrettable incidents.

Henry felt he ought to do something spiritually for the people who lived in his parish for several weeks, and gave so much amusement to others. So down to the fairground he went one Sunday afternoon and knocked at the door of the proprietor's caravan. 'He's out on the beach,' said his lady, roused from her Sunday afternoon nap. Henry went to the beach, and seeing some of the fair men lying sleeping in the sun, went up to one of them and asked him to point out the proprietor. The man was not pleased at being roused, gave one look round, pointed at a man sitting with a woman alone at the water's edge, and said 'That's him,' and lay down again. 'I have not that honour,' said a pleasant summer visitor. Henry apologised profusely, and the visitor seemed more amused than annoyed, and later on when the two families got to know each other, the first introduction was a matter of jest between them.

Nothing daunted, Henry tried again with better luck. The right man having been found it was arranged that the vicar should conduct a brief service at the fairground after Evensong in the church. He took a plentiful supply of hymn books, and got members of his congregation who could sing to go with him.

The proprietor was gracious and helpful, ordering naphtha lamps to be lit as the summer dusk deepened, and he himself stood close to Henry throughout the brief service. The caravan people gathered round in full strength, joined in the singing and thanked the vicar for coming.

'I expect you know my son?' said Henry blandly to the proprietor.

'Yes, I do,' was the rather grim answer; the special emphasis was lost upon Henry which was well, for if he had known the reason it would have greatly distressed him.

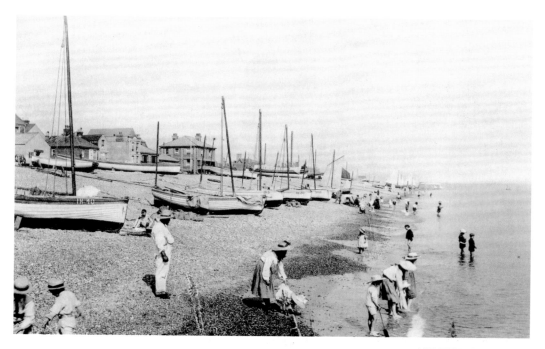

ALDEBURGH BEACH

His young son was mathematical, and observant, and he evolved what he called his 'system', and whenever he put his coin on the roulette board it proved a winner. It became such a recognised thing that he knew how to win, people waited until he came, followed him to the roulette board, and put their coins on the top of his. The local beachmen stood behind him waiting for his lead, and he had unhappy qualms about always playing for a win, but it was so interesting to see the plan succeed.

Dorothy Thompson

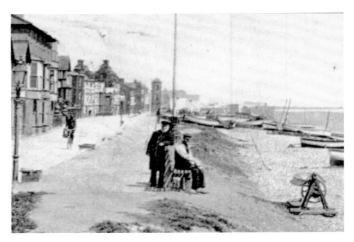

ALDEBURGH

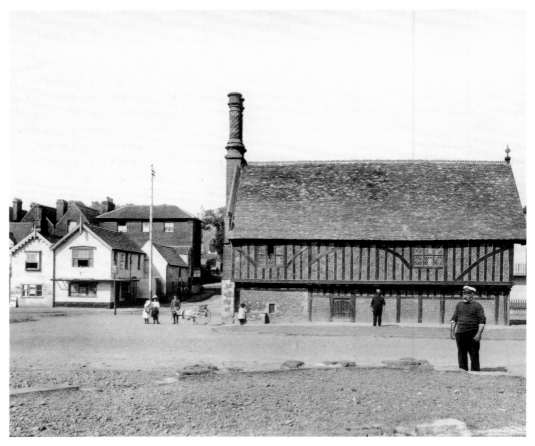

MOOT HALL, ALDEBURGH

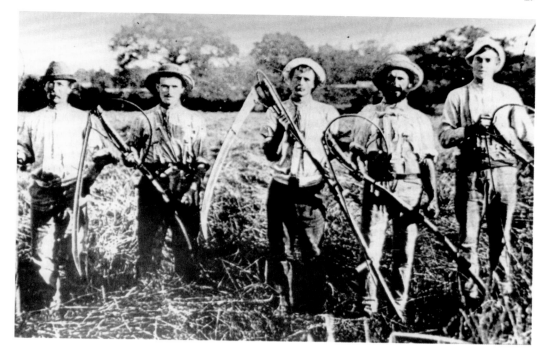

SCYTHING AT SPRING FARM

FARMWORKERS

In this country, where such labourers as remain on the land are practically *adscripti glebae*, there are always men who know the history of a particular field for the last one or two generations. Thus, when I was draining the eight-acre, No. 2, here, with tile drains before it was laid down to permanent pasture, I remember some old pipes, of the sort that were used many years ago, measuring about an inch and a half in diameter, being turned up by the drainers, filled, each of them, with a core of stiff clay. An old man was standing beside me watching the operations. 'Ah!' he said, addressing the pipe, 'I remember a-carrying of yow when I wore a lad more nor seventy yir ago.' It transpired afterwards that in this remote period the old gentleman had been employed to place these narrow pipes—then, I believe, a new-fangled agricultural luxury—in little heaps ready to the hand of the man who laid the drains. He also told me, by the way, that in those days the field in question was common land, which someone enclosed and drained.

It is the fashion, especially in the comic papers, to talk of the agricultural labourer as Hodge—a term of contempt—and to speak of him as though he had about as much intelligence as a turnip. As a matter of fact, after a somewhat prolonged experience of his class, I say deliberately that, take it all in all, there are few sections of society for which I have so great an admiration. Of course, I am excepting black sheep, brutes, drunkards, and mean fellows, of whom there is an ample supply in every walk of life. But, on the other hand, I am excepting also any specimens palpably above the general level, and talking of the man as one meets him everywhere upon whatever farm one likes to visit.

Let us take the problem of life as it presents itself to that *rara avis*, the stay-at-home agricultural labourer of today. He has received some education—for, supposing him to be a man on the right side of forty, the Board schools had begun in his time—but he does not trouble himself much about learning. As soon as he was out of school he began work on a farm in his parish, and at nineteen or twenty, following a natural and proper impulse, he took to himself a wife. From that day, earlier than is the case with any other class of society, his responsibilities began. Being still so young he would not be trusted in any of the higher positions on a farm, such as that of horseman, but his work would be that of a general labourer earning, let us say, an average wage of about thirteen shillings a week, including his harvest. Within five years he would have at least three children, perhaps more,

and within twelve years seven or eight living, all of whom must be supported by the daily labour of his hands, and who, in nine cases out of ten, are so supported. Besides providing for these children, he pays the rent of his cottage, 3/. or 4/. a year, and, if he is a prudent man, a subscription towards an Oddfellows or other benefit society, which makes him an allowance on the rare occasions when he falls sick or is disabled by accident. It is during these first seventeen or eighteen years of his married life that the burden of existence falls most heavily upon him, since there are many mouths to feed and only one pair of hands to provide the food. Still, in the vast majority of instances, it is provided, and, what is more, if his wife be a managing woman blessed with fair health, the children are sufficiently, and in many instances neatly, clothed. Often, when passing the school of this parish as the scholars are coming out of it, I have noticed and wondered at their general tidiness and good appearance. Not one of them looks starved, not one of them seems to be suffering from cold; indeed, any delicate youngster is provided with a proper coat or comforter.

Afterwards, when his family is growing up, our labourer's long struggle against want becomes less severe, for the boys begin to earn a little, some of which finds its way to the general fund, and the girls go out as servants, kitchen-maids, or 'generals', in situations where they are well fed and paid enough to dress themselves, leaving a pound or two in their pockets at the end of the year. So matters go on until our friend becomes old, which common misfortune overtakes him about the age of seventy. Then it is that too frequently the real tragedy of life strikes him. He is no longer able to do a full day's work, and in these times, when the best of farmers can scarcely make both ends meet and earn a living, it is not to be expected, indeed it is not possible, that they should continue to pay him for what he cannot perform. Therefore, if help is not forthcoming from his children or other sources, he must sink to the workhouse, or at least upon the rates.

H. Rider Haggard

THE FARMWORKER'S LOT

If you argue this question of the labourer's lot with farmers, who, as a class, are very severe critics of the actual tillers of the soil, they will point out that, owing to the fall in the price of provisions, although wages are so low, his circumstances are better than they were fifty or a hundred years ago. This is doubtless true, but they neglect to explain what his position was at the beginning of the century. Those interested in the question can easily study it

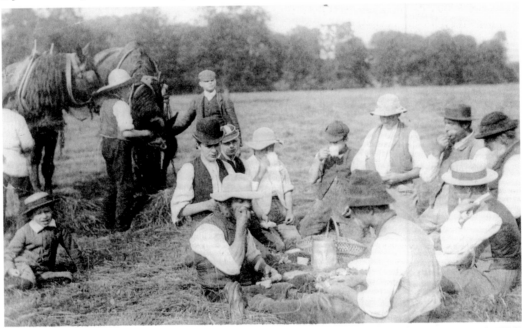

MEN TAKING THEIR 'BEAVERS'

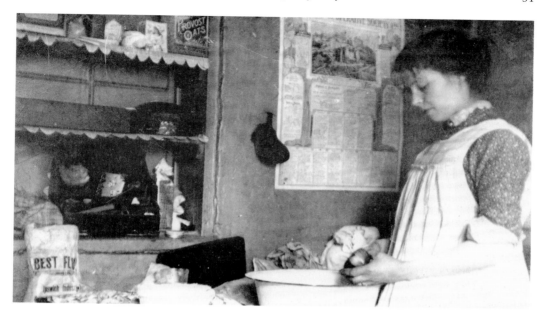

A COTTAGE KITCHEN

in the pages of various writers, but to my mind the marvel is that when wheat was selling for 5l. or 6l. a quarter, and cottages were mere mud-hovels, the race continued to exist. On this property, not a quarter of a mile from my house, there stands a shed built of clay-lump, and roofed, I think, with faggots; it may measure sixteen feet in length by about ten in breadth, and inside is divided into two parts, now tenanted by calves. In that shed an old lady—not of the poorest, for she planted a large orchard—reared a numerous family. one of whom was for many years my groom. Nowadays the cottage which I provide upon the holding contains two sitting and several bed rooms, with ample offices—an instance that shows how in this respect things have changed for the better.

Sometimes I wonder whether any labourers will be content to stick to the soil at the present scale of remuneration. Doubtless the older men at present employed upon it will do so because they must, but how about their sons? The education which they receive at the schools teaches them that there are places in the world besides their own Little Pedlington, with the result that already there is an enormous influx into the towns, where wages are higher—for those who can get them—and life is more lively.

That the people go somewhere is proved by the fact that in spite of its great increase throughout England, the population of our villages is rapidly waning, and that really skilled farm hands, men who can plough, thatch, drain, and milk, are becoming more and more difficult to find. At present, however, I do not think that the surplus gets much further than the cities. In the future, as their minds become accustomed to the idea, and they grow to understand how great are the opportunities of the British Colonies, perhaps the young men will drift thither. At present bricklayers in Bulawayo are being paid a pound and an ordinary labouring man ten shillings a day, and were he less stay-at-home these are prices that might tempt Mr Hodge to travel, especially as in those lands Jack is as good—or rather better—than his master.

H. Rider Haggard

CEASELESS NATURE OF FARM WORK

April 5.—Last Saturday, the 2nd, we had another frost, followed by a fine day. Sunday was cold and cloudy; Monday also cold with sunshine and a high wind, west and nor'-west; today also cold, wind east to south, with intervals of sunshine. The work is the same as that of last week: grass harrowing, manure-spreading, and baulk-splitting, not very interesting operations, any of them, but absolutely necessary. Compared with other and rougher countries, it is curious to note the ceaseless nature of the work needful to the carrying on of an English farm.

Although it is the fashion among people who know nothing about him to hold up the English agriculturist as the commonest of fools, he has brought cultivation to such a pitch of science that every day demands its appropriate and necessary labour, without which all would be spoilt. Yet the pity of it is that, notwithstanding the care, knowledge, and intelligence which are put into the working of the land, under present conditions it can scarcely be made to pay. The machinery works, the mill goes round; the labourers, those who are left of them, earn their wage, such as it is, and the beast his provender; the goodman rises early and rests late, taking thought for the day and the morrow, but when at Michaelmas he balances his books there is no return, and lo! the bailiff is glaring through the gates. Although there have been gleams of hope during the past year, in our parts the ancient industry of agriculture is nearly moribund, and if the land, or the poorer and therefore the more considerable portion of it, is farmed fairly, it is in many instances being worked at a loss, or at any rate, without a living profit.

H. Rider Haggard

VILLAGE FAMILY LIFE

Arthur William Welton (born 1884) was brought up in Benhall, Suffolk; and his early memories add a few details to the picture of village family life at the end of the last century:

As a boy I kept a few chickens and also tame rabbits. Because a tame rabbit made a good Sunday dinner. I remember that we kept the feathers from the chickens or any birds we had; they were kept and when there was the weekly baking of bread, after the bread was taken out, the bag of feathers was put in the old brick oven to dry, and purify 'em, we used to say. And when this had been done, they clipped the stalks from the feathers, and with them they'd made the feather-pillows. And if there was one of the family getting married, the mothers used to make a featherbed. And that was the wedding present, a feather bed—a home-made feather-bed!

I recollect the women, they were always busy: they were never idle. There was always work to do: they would make string rugs, and the children they would get the hessian, or a new sugar-bag, cut strips, pull the string out and make a string-mat. Then there was the cloth mats, cut-up clothes what was discarded. They were washed,

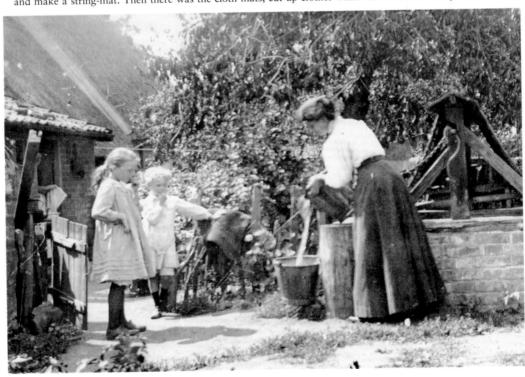

BILDESTON

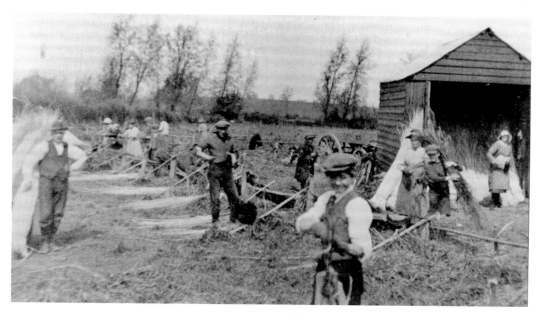

OSIER BEDS AT STURMER END, HAVERHILL

cut up into shreds; and then to make them look neat and smart they would buy a soldier's red coat. From that soldier's coat a heart was made in the centre of the rug, and at the far corners there was the diamonds. But the best ones of the lot were the wool-made rugs. They used to make the wool rugs because there was a lot of wool used at that time. You had long stockings and the children had little socks; and when they got worn at the foot they would re-foot these stockings. What wool was to spare went into making these wool-rugs. And when there was a cold winter, many a time that wool-rug was kept and put on the bed. But we didn't have hot-water bottles because there was so many in the bed. We kept each other warm. We lay pretty close together in the bed: there was several in one bed; because, you see, the people in the country, most people, had large families then.

Through the memories of the older people who were born before the prior culture started to break up we can also get individual glimpses of rural life: for instance, the isolation that comes through in a conversation about an old American clock. Albert Love talked about the clock he had bought as a young man in the Norfolk village where he was brought up:

'Yes, yes, that clock's a very interesting one. That's an old one! There's a big history to that. Oh, yes, that's the old time-keeper for the village of Alburgh, where I was bred and born; the village of Alburgh. A man named Parhams, Mr Parhams—an old man; he used to do a little hair-cutting and shaving old people. And he had this clock in his little old room where he lived in. That was the main time-piece for Alburgh to get the time by. This would be—I don't know how long ago! But he was an old man and he had it all his lifetime. He had this clock, and he used to ask anyone that carried a watch and went into Harleston to do a little shopping whether they would bring him the right time home to keep his clock going. The right time, because there wasn't any means of knowing the time in the village. They used to bring him the time home; and that clock would go within a minute for twelve months; didn't vary a minute in twelve months. They reckon that was the best time-keeping clock—well, in this village. There was no church-clock, no town-clock, no nothing; just the village, and practically no clock in it.

'The old people used to go to work in the fields; and they would hold the hoe-handle up, a fork-shaft or anything, and take the shadow. They didn't know the real time. You'd never see one in ten or twenty had a watch or anything to go by. No, it was all timeless. And they used to go and get the time off this old clock.

'Well, the old boy told me in about 1905 or 1906, might be 1907 that he'd have to sell this clock. He said: "I want some clothes. I'll have to sell the clock."'

George Ewart Evans

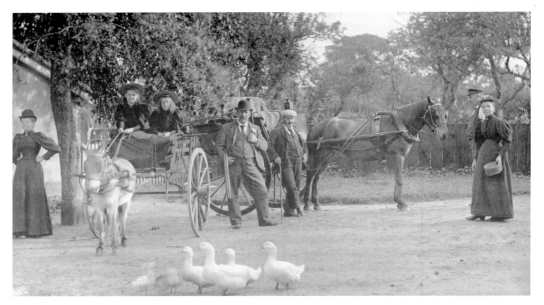

A SUFFOLK FARMYARD

ASPALL

Six or seven parish boundaries touched ours, for the acreage of Debenham was large. Of these parishes, Aspall was by far the most closely linked with us, for two fingers, as it were, of our parish ran far along the east and west borders of Aspall. Since it possessed no shops, no public house, and no craftsmen of its own, the wants of the inhabitants were supplied from Debenham. But it made one important contribution to the government of its larger neighbour, for the Vicar of Aspall, the Revd C. H. Chevallier, was the sole magistrate in the immediate neighbourhood. The threat that 'I will have you up afore the Reverend Charles Hinnery' might be heard now and then during a wrangle in Debenham.

Aspall parish was more picturesque than most of the country round us, for the Aspall river, as we named one of the two contributories of the Deben, ran for much of its course between high banks and copses adjacent. Not far from the hall was Aspall Wood, the only wood of considerable size in the neighbourhood. It contained standard oaks of large size, some fine old Scots firs and several acres of 'ash stools'. Ash stools, not often found in woods, are useful as a minor branch of forestry. Every few years the long, straight ash poles growing from them would be cut for use and purchased by wheelwrights or carpenters of Debenham. Spenser wrote:

> The aspine good for staves, the ash for nothing ill

and truly the number of uses to which ash can be applied is immense.

In winter enormous flocks of wood-pigeons often came to roost in Aspall Wood. The rabbits seemed to be particularly fond of sitting in the big, half-hollow ash stools, 'stub rabbits' they were called, and a few wild pheasants might be found. The Rookery Wood in the valley to the west was the home of a vast number of rooks, for they had been reinforced by those who quitted the Debenham rookery because of the carrion which had been hung there when they were nesting. I think that there was no place for miles around Debenham which possessed so many varieties of birds as Aspall. The jays raided the rows of peas in the garden. Nuthatches nested regularly close to the Hall. Wild ducks occasionally bred near by. In winter moorhens by the dozen fed with the fowls and ran across the lawn. Nightingales came to the copses by the road, and at least one pair of kingfishers tunnelled in the bank of the stream. There were sparrowhawks in the wood, especially in winter, and white owls. There were also, of course, all the commoner small birds, among them redstarts, whose lovely blue eggs seem to be in keeping with the picturesque colouring of the male bird. It was a wonderfully attractive place, especially for young people.

James Cornish

DUNWICH

I defy any one, at desolate, exquisite Dunwich, to be disappointed in anything. The minor key is struck here with a felicity that leaves no sigh to be breathed, no loss to be suffered; a month of the place is a real education to the patient, the inner vision. The explanation of this is, appreciably, that the conditions give you to deal with not, in the manner of some quiet countries, what is meagre and thin, but what has literally, in a large degree, ceased to be at all. Dunwich is not even the ghost of its dead self; almost all you can say of it is that it consists of the mere letters of its old name. The coast, up and down, for miles, has been, for more centuries than I presume to count, gnawed away by the sea. All the grossness of its positive life is now at the bottom of the German Ocean, which moves for ever, like a ruminating beast, an insatiable, indefatigable lip. Few things are so melancholy—and so redeemed from mere ugliness by sadness—as this long, artificial straightness that the monster has impartially maintained. If at low tide you walk on the shore, the cliffs, of little height, show you a defence picked as bare as a bone; and you can say nothing kinder of the general humility and general sweetness of the land than that this sawlike action gives it, for the fancy, an interest, a sort of mystery, that more than makes up for what it may have surrendered. It stretched, within historic times, out into towns and promontories for which there is now no more to show than the empty eye-holes of a skull; and half the effect of the whole thing, half the secret of the impression, and what I may really call, I think, the source of the distinction, is the very visibility of the mutilation. Such at any rate is the case for a mind that can properly brood. There is a presence in what is missing—there is history in there being so little. It is so little, today, that every item of the handful counts.

The biggest items are of course the two ruins, the great church and its tall tower, now quite on the verge of the cliff, and the crumbled, ivied, wall of the immense cincture of the priory. These things have parted with almost every grace, but they still keep up the work that they have been engaged in for centuries and that cannot be better described than as the adding of mystery to mystery. This accumulation, at present prodigious, is, to the brooding mind, unconscious as the shrunken little Dunwich of today may be of it, the beginning and the end of the matter. I hasten to add that it is to the brooding mind only, and from it, that I speak. The mystery sounds for ever in the hard, straight tide, and hangs, through the long, still summer days and over the low, diked fields, in the soft, thick light. We play with it as with the answerless question, the question of the spirit and attitude, never again

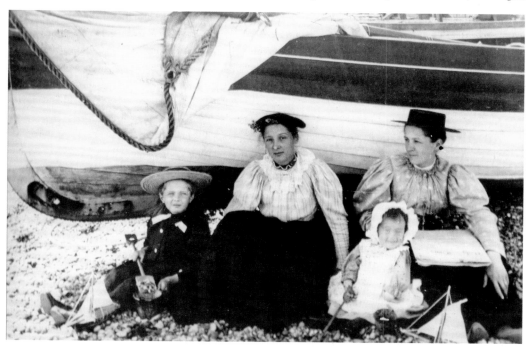

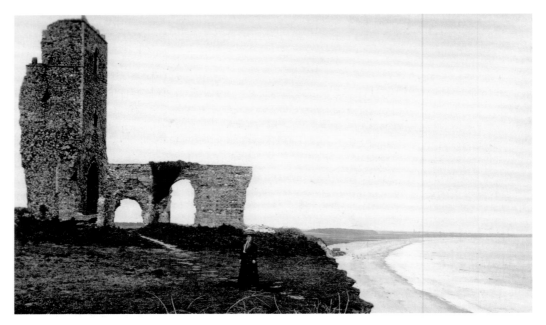

RUINS OF ALL SAINTS' CHURCH, DUNWICH

to be recovered, of the little city submerged. For it was a city, the main port of Suffolk, as even its poor relics show; with a fleet of its own on the North Sea, and a big religious house on the hill. We wonder what were then the apparent conditions of security, and what rough calculations a community could so build itself out to meet its fate. It keeps one easy company here today to think of the whole business as a magnificent mistake. But Mr Swinburne, in verses of an extraordinary poetic eloquence, quite brave enough for whatever there may have been, glances in the right direction much further than I can do.

Henry James

CHARACTER OF SUFFOLK

Of the many autumn visitors to the country, which rejoices in the sobriquet of 'silly Suffolk', few perhaps think of it save as the home of pheasants and partridges innumerable: and it is true that its warmest admirers can claim for it nothing by way of scenery beyond the quiet home beauty which Gainsborough and Constable delighted to paint. It possesses, however, a peculiar character of its own. Cut off as East Anglia has always been, more or less, from the rest of the kingdom, its inhabitants to this day look down upon 'the shires' as a foreign and very inferior country. Many old customs still survive there, and much of the peculiar dialect which schools and School Boards are rapidly driving out, to the sorrow of philologists and antiquarians. Still, in harvest time, the labourers will come up and ask for a 'largess'; a girl is still called a 'mawther' and a snail a 'dodman'. If you ask a cottager how she is, the answer will either be that 'she fare wunnerful sadly' or 'she fare good tidily'—each sentence ending on a high note which makes the 'native' or home of the speaker perfectly unmistakable, even if encountered in a distant county. If you ask after her little boy, 'he is minding the dicky' (*anglice*, donkey); if you talk of the crops, you are informed that 'there's a rare sight o'roots t'year'. The words 'cover' and 'covey' are employed by a Suffolk keeper in exactly the reverse sense of that usually ascribed to them, while still stranger perversions of language occur in the use of the words 'lobster' for 'stoat' and 'screech owl' for 'stone plover'. The people are generally a clean, honest and industrious race, famous for making good servants, and chiefly employed in agriculture and fishing; there being, with the exceptions of Messrs Garrett and Ransome's great agricultural implement manufactories at Leiston and Ipswich, but few manufactories of any kind.

Quarterly Review, *No. 328, April 1887*

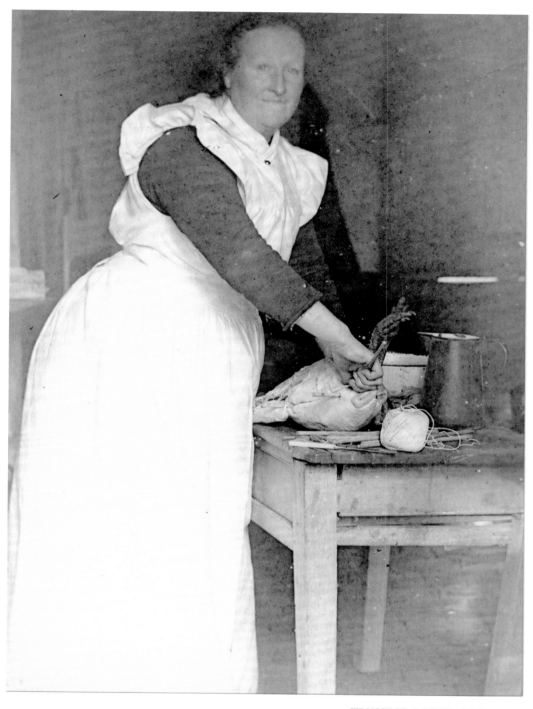

TRUSSING A FOWL, PLAYFORD

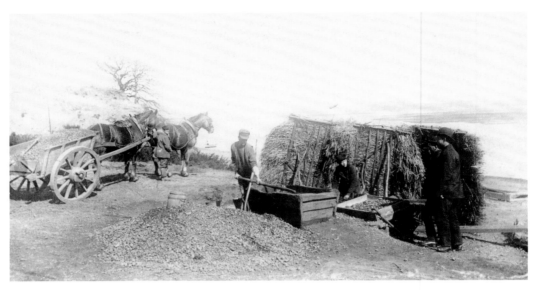

WASHING COPROLITE BY RIVER DEBEN AT WALDRINGFIELD

FISHING TIME

There was the fishing-time. You needed to get busy at the fishing-time when the home-fishing started about September. There'd a firm come right away from Scotland; he come right down to Lowestoft and Yarmouth, Barney Sutherland his name was; and he'd bring about forty or fifty horses down there. And there'd be all these here little fish-carters, you know, at Lowestoft and Yarmouth. We used to supply them with hay and with horses. We used to supply—let them have a horse for the fishing time: you were sure of selling your hay to them then, you see. No, we never bought from Barney Sutherland; we used to buy horses off the farm. We sold to Barney Sutherland. But he'd bring a lot of Scotch horses down; and after the fishing was over, Christmas time, he'd have a sale and sell them; good young horses. Three years old some on 'em. Yeh, you got a good class of horse from him. He'd bring some good horses down from Peterhead. Well, they used to come from all around there. He used to follow all the fishing round. These Scotch girls also used to come down. I went—about the first load I ever went was down to Lowestoft; but I'd been several times before when I used to ride down with my father. But I went with this load on my own, a one-horse load when I first started to drive; went to a place up the Raglan Road; Long and Flemings the name was. They used to have a lot o' these Scotch girls there. I put the load of hay in the yard, and there was no one there to help me unload it. These chaps were out, busy fish-carting. I just looked in to one of these buildings there, where the Scotch girls were all working at the troughs, cutting the herren. I was so interested in watching them. Then all at once there's a fish come. I don't know where that did come from. But that hit me in the mouth! I left this building after that in a hurry. These women; they were all Scotch women. You'd see them when they'd finish a trough of herren, they just down with the old knife (their fingers were all bound up with sort of string, all round their fingers) and they'd just get hold of their knitting. They'd go with their old shawl round them. They'd be a-knitting in about five minutes afterwards. That was very exciting, you know, at that time.

George Ewart Evans

LOWESTOFT FISHING PORT

Well before the 1880s Lowestoft had become a fishing port of considerable importance. Local drifters and trawlers, many of them built at the port, were designed to meet and overcome the harsh conditions encountered on the North Sea grounds. They were graceful and they were fast, and the men who sailed in them gained an enviable reputation for seamanship and skill.

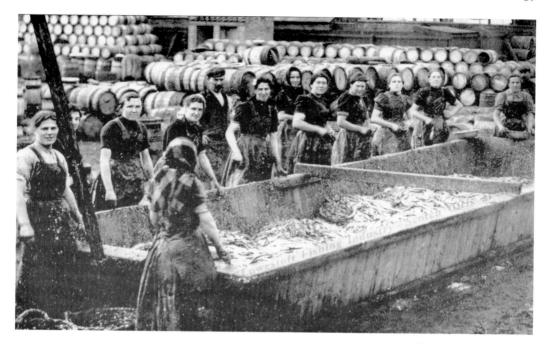

SCOTCH GIRLS AT LOWESTOFT

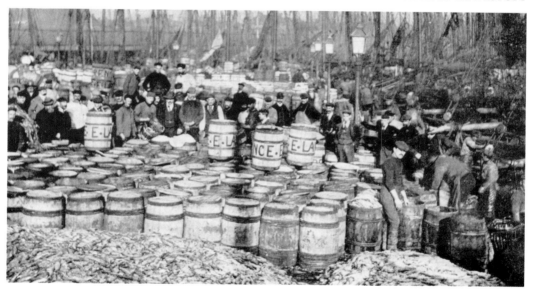

FISH MARKET, LOWESTOFT

Nearly all the vessels in the local fleet were clinker built, but in 1876 the local Richards yard turned out the 52-ft fishing dandy *Nil Desperandum*, a carvel built drifter which was the forerunner of many similar vessels built at the port. A drifter of this type would be completed, ready for sea for as little as £360, and even allowing for the vastly increased purchasing power of the pound in those days the craft were clearly considered to be good value for money.

One vessel in this mould which passed into local legend was the drifter *Paradox*, built by Richards in 1884 for Walter Haylett, of Caister, and a craft which was reckoned to be able to leave most other sailing ships of her size well astern in any race.

By 1898 there were nearly 500 fishing vessels registered at Lowestoft, half of them sailing drifters and the rest sailing trawlers. Each autumn the local fleet was joined by the rakish visitors from Scottish waters, fifies and zulus with their dark brown and black sails complementing the red and tan of the canvas worn by the local fleet.

What was life like for the Lowestoft fishermen in those latter years of the nineteenth century, when it seemed both to them and to the proud local owners that nothing could ever displace the sailing craft which had been perfected by long experience?

Out on the fishing grounds of the North Sea there was little that was picturesque about fighting for survival in the teeth of a raging gale, even on board the sturdiest of smacks. Casualties among ships and men occurred with grim regularity. Many vessels came to grief within sight of home, when the tricky approach to harbour in bad weather could defeat the most skilful of skippers, and the beaches and inshore sandbanks claimed many victims. There were other hazards, too, facing the fishermen. The notorious Dutch copers, or grog ships, were invariably in evidence on the grounds where the fishing fleets assembled, and talk of the evils of drink had a very real meaning when the liquor supplied was the vicious aniseed brandy served up by the copers.

The evils of the copers were finally overcome through the magnificent efforts of the Mission to Deep Sea Fishermen. It was the Mission which determined to meet the needs of the fishermen by taking out to the grounds well equipped ships able to supply not only cheap tobacco (which was a powerful inducement for men to visit the copers), but also sorely needed medical attention.

Before the arrival of the Mission ships in the early 1880s there was little which could be done for the fisherman unfortunate enough to suffer injury—and injuries were caused all too often in the course of such hazardous operations as that of taking fish by small boat to be transferred to a fast carrier vessel.

Neglect and exposure caused terrible suffering at times. There was the case of a smack hauling in bad weather on the Silver fits and which was struck by a heavy sea just as the beam trawl had been got on board but not secured. The force of the water swept the gear back into the sea, smashing the skipper's leg as it went. The accident happened on a Tuesday, and for three days after that the smack rode out a gale while the skipper had to fend for himself in the cabin until his injured leg could be lashed to the side of a fish trunk. Then, on the Saturday, he was transferred to a steamer, and not until the Sunday evening was he ashore and receiving expert attention. Another man who fractured a thigh remained untreated for nine days aboard a smack before he could be got back to port.

Looking back to his boyhood, a fisherman of the time recalled that for the first five years of his seagoing experience as an apprentice on board a sailing smack he never knew what it was to have a proper berth. He was expected to doss

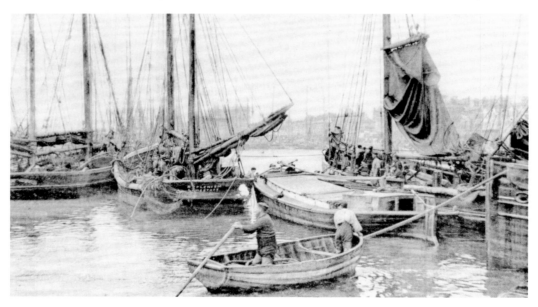

LOWESTOFT

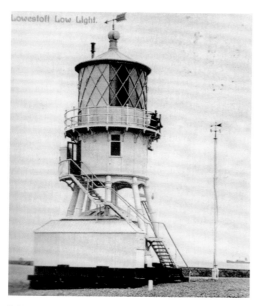

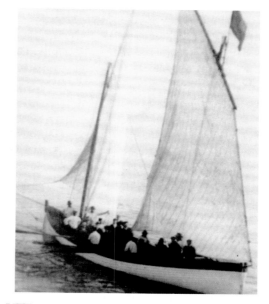

LOWESTOFT LOW LIGHT

BITTEN YAWL RETURNING TO SOUTHWOLD

down on an old piece of netting in the fo'csle—and to do without such amenities as heating or a change of clothing.

Another man, also at sea during much of Queen Victoria's long reign, looked back to his own apprenticeship on board a fishing vessel when 'the time was spent at sea in lying, swearing, card-playing, fighting, sing-songing and telling ghost tales and stories about witches, which they for the most part were believers in'.

The following extract from an article in the *East Anglian Daily Times* of 11 April, 1887, gives a good impression of what living conditions entailed for hundreds of smacksmen when they came off duty.

It is frequently past noon before the morning's catch is disposed of, and the weary hands are glad enough to go below to get their breakfast, throw off their oilskins, and perhaps their seaboots and turn into their bunks. But there is little comfort in the cabin of a smack. It is a badly lighted, unventilated hole, about eight feet long and four or five feet high. The temperature is unpleasantly hot, generally between seventy and eighty degrees. The atmosphere is stifling. The smoke of strong tobacco and the fumes of cooking combine with the reek of damp oilskins and jerseys and a hundred other evil odours.

The landsman, stifled and nauseated, is soon driven to take refuge from suffocation on deck, and to face again the driving spray and the bitter wind.

Hard though conditions were on the old drifters and smacks, there were times when happier moments came along. Pride in the abilities of local craft and their crews, for example, led to the establishment of a whole series of races off the Suffolk port, when the pick of the fleet competed in thrilling contests which were often decided only by a matter of seconds.

Peter Cherry and Trevor Westgate

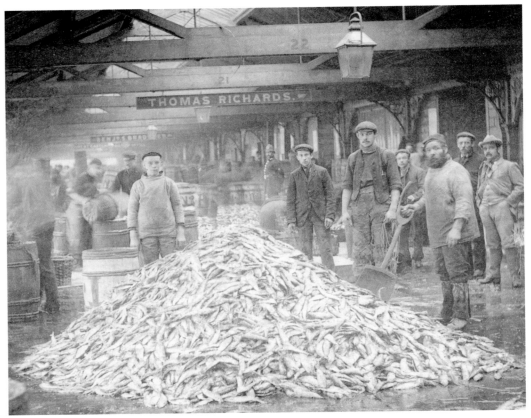

LOWESTOFT

FISHERMEN'S FOOD

The cook of one Lowestoft smack could recall frying a bucketful of fish for a single meal. Small plaice, gurnards and weevers found their way into the pan together with soles and plaice, and each man in the crew took between a dozen and eighteen fish as a first helping. It was, according to the cook in question, an awe-inspiring sight to see the men tucking into these great mounds of fish, with the meal liberally sprinkled with vinegar and mustard sauce.

No Suffolk fish eating championship was ever organised officially, but outstanding feats were now and again recorded and passed into local legend. Among the most remarkable of these achievements were those attributed to the Lowestoft fisherman Amos Beamish—the 'giant of Barnby'—who was reckoned to regularly eat thirty herring at a sitting. Perhaps it was his healthy liking for a fish diet which helped Amos to achieve and maintain his size and strength. Even among the fishing fraternity, where there is no shortage of big, strong men, Amos achieved an enviable reputation. When he served on drifters it was said of him that on one vessel the hatchway had to be specially enlarged so that he could ease his great bulk down to the cabin. But owners were always glad to have him on board as a member of the crew, for he was able to do the work of two normal men.

On one occasion, for a bet, Amos ate a really fantastic meal, when he got through one hundred spring herring. But he met his match that day, for sitting at the table with him was one 'Scarlet' Bryant—who somehow managed to eat one hundred and one fish.

There was a time when many Lowestoft drifters went to Newlyn to take part in the mackerel fishery, and it was during one of these westward voyages that the Barnby giant added further laurels to his reputation as a man of outstanding strength. That was when he took on the local champion and each man attempted to lift a rock weighing over 60 stone. Beamish took a firm grip on the great boulder and lifted it with hardly a grunt. His opponent could not budge it when his turn came.

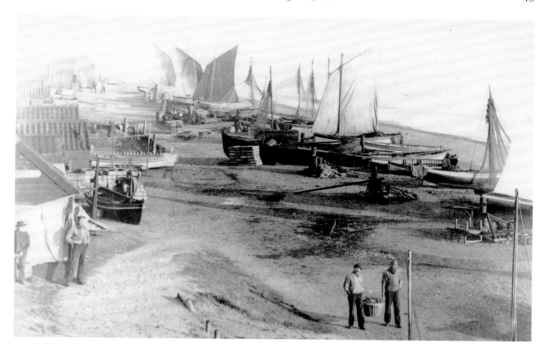

SOUTHWOLD BEACH

His most remarkable feat of strength was at the time of Barnby train disaster at Christmas, 1891. Amos was one of the first people on the scene of the crash, which happened a short distance from his home, and he worked tirelessly in helping to free people trapped in the wreckage. One account of the rescue work said: 'Foremost was Mr Amos Beamish, a man of almost gigantic strength, which he turned to such good account as to make one almost believe it was specially increased for the occasion.' Legend has it that alone he lifted the end of one coach to free the people trapped beneath.

Like many of his fellow fishermen, Amos Beamish was particularly fond during his time at sea of a meal consisting of fish taken straight from the net, cleaned and popped into the pan. The cooking technique he knew was rough and ready—but the outcome was a dish as tasty and succulent as could be found in the finest kitchens ashore.

On board a typical drifter of his time the herring destined for the table would be swiftly gutted, then 'topped and tailed' and slashed along each side with a jack-knife before being consigned to the frying pan. Served up piping hot the fish would be eaten by the crew with their fingers. Cutlery tended to be in short supply on the old time fishing vessels and, in any event, eating in this way left a hand clear to stop the plate sliding around too much.

Peter Cherry and Trevor Westgate

SOUTHWOLD HARBOUR

In 1898 a Board of Trade authority was obtained, abolishing the old Commissioners and vesting the harbour in the Corporation. This was the period when the herring fishing had become extremely prosperous and upwards of 1,000 of the largest Scottish sailing drifters used to come south to Lowestoft and Yarmouth to finish the season. The result was that both harbours became so congested that boats could not get to sea at times for days together, and those with catches had great difficulty in getting berths, to discharge. Eventually a scheme was worked out with the Board of Trade and Messrs Fasey, London contractors, for the development of Southwold as a fishery harbour to relieve the congestion. The Government gave grants amounting to £21,500 and Faseys were to find the rest, conditional on the harbour, with certain adjoining land being conveyed to them free. A further Board of Trade order was obtained in 1907, the work having been started in 1906 to be in time for the 1907 autumn fishing, but in consequence of opposition by the town and law proceedings being initiated, valuable time was lost, and the harbour

not being ready, the Scottish drifters cancelled their plans and there was no fishing done worth speaking of. In 1908, fishing and curing began. Some 300 boats used to visit us, 300 trunks of trawl fish, about 4,500 crans of herrings and 125,000 mackerel were landed, and the Southwold ships *Nisse* and *China* sailed for Germany with 2,100 and 3,212 barrels of cured herrings—the *China* drawing fourteen feet of water. Ordinary trading returns came to 6,483 tons. The year 1909 proved very poor for fishing, with constant gales, but I had the great pleasure of seeing seventy of the great Scotch luggers enter the harbour on a single tide, but with few catches owing to the weather, which kept them idle for over a week. Still, over 7,000 crans of herrings were landed that year, 1,200 trunks of trawl fish and 350,000 mackerel and 761 fishing craft used the harbour. The German SS *Sophie of Dantzig* sailed in November, 1909, with 4,436 barrels of cured herrings and drawing fourteen feet of water, the deepest draft ship ever to leave Southwold Harbour. By a coincidence the largest ship to enter was also a German, the *Grossherzog Frederick Franz IV*, 596 tons registered, 220 feet long, which came on 13 November, 1912, and took in fifty tons of bunkers; most of the little coasters which used to belong could have gone inside her.

E. R. Cooper

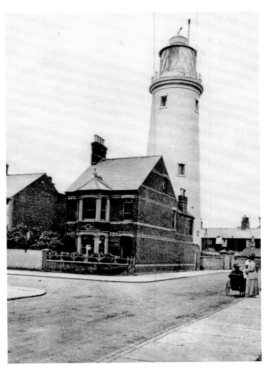

SOUTHWOLD LIGHTHOUSE

THE SOUTHWOLD RAILWAY

Although I have never jumped off the little train while in motion, picked flowers and scrambled back to my seat in the tram-like coach, I remember a rather unusual experience one fine day many years ago.

It was during the summer of 1888. I was travelling with other members of the Ipswich Gospel Male Choir to Southwold where we were to give a concert. We started off from Halesworth terminus and were soon careering along at 12 m.p.h. when the conductor, Mr Wright, a well-known local figure, came along to examine tickets. I told him I was getting off at Wenhaston and continuing the journey by a later train, whereupon he said excitedly: 'But we've passed Wenhaston.'

He then promptly stepped to the front end of the coach and screwed the brake on hard so that the driver could notice the 'pull' and looking back from the engine footplate see the conductor violently signalling him to stop—which he soon did, allowing me to get down and retrace the quarter-of-a-mile along the rail track back to the station.

Letter from G. A. Mallett, East Anglian Magazine, September 1954

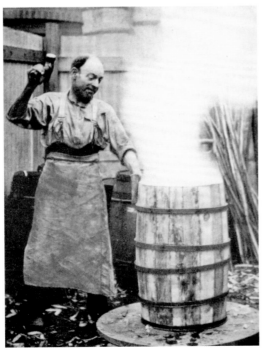

HERRING BARREL MAKING

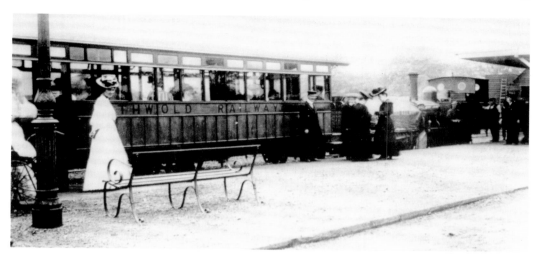

SOUTHWOLD RAILWAY STATION

EXTRACTS FROM THE DIARY OF A YOUNG MAN OF IPSWICH

1892.

13th September. For some time ill-feeling has existed between two labourers living in the Beaconsfield Road (Ipswich), McCabe and Francis. On Saturday after a few words M'Cabe followed Francis into His (Francis's) house, and struck him a blow on the eye and also on the head. The wound bled but was not thought so serious till Sunday when the man became worse and died shortly before midnight. M'Cabe was arrested by P. C. Hammond on Sunday night. An inquest was held on Monday and adjourned.

20th September. Verdict of wilful murder returned against M'Cabe.

5th October. Wet and nasty. A sale of work at the Presbyterian Church room. Yesterday a Grand Welsh Concert on at the Public Hall. Mr C. Evelyn Jones, also a thought reader and the lady who lifted the Czar (?) at the Lecture Hall. Tried for a place on the Colonial Tea Trading Association. No avail.

6th October. I tried for a place at Nash the Butter King.

13 October. Received a Post Card from Thos. Parkington & Son offering me a situation in their office, went to see them and am to let them know on Monday.

15th October. Long hours at business (grocer's) 8 a.m. to 10p.m . . .

17th October. Went to see Parkington & Son, Builder etc., St Margarets Works, Crown Street, Ipswich and am engaged T.G. to start work on Saturday at 7s. per week. Hours 8 a.m. to 6 p.m. and 1.30 p.m. on Saturday.

22nd October. Started at Parkingtons. It took us all the morning to get ready to pay the men. About 60 of them paying out about £62 odd. . . We had some snow this morning.

27th November. Went to hear Jack Rogers the coloured Evangelist . . . He came over to England and first started in a public house playing a piano, singing, dancing, etc . . . He was soon married and the same afternoon converted, his wife died about 16 months after their marriage and at her funeral Rogers stated there were 25,000 persons present.

29th November. Mother and Mr Gibbons went to hear Rogers give his farewell Lecture in the Clarkson Street Chapel. He has been a carpenter, body snatcher, fallen among Spaniards, nearly murdered a man . . .

3rd December. M'Cabe for the murder of an Ipswich plate layer was found guilty and sentenced to death at the Assizes. The business at the assizes did not terminate before midnight on Saturday.

Monday. Freezing all day. Pooles Myorama has been at the Public Hall . . . 'Held by the Enemy' is now being played there. Carl Steventon, the only real sleight of hand and mesmerist in the world is at the Lecture Hall.

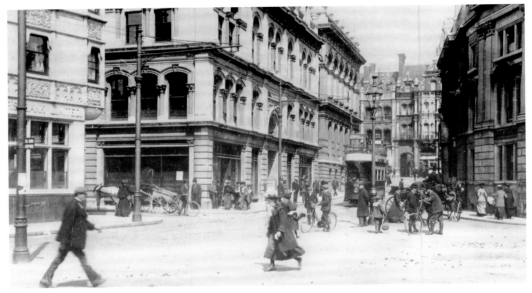

PRINCES STREET, IPSWICH

Friday. Have been round with a petition to get M'Cabe of [sic] being hung. 30 signed.

Wednesday. The Home Secretary has advised the Queen to commute the sentence of death passed upon Jim M'Cabe to penal servitude for life.

Thursday. The Largest Tea, Coffee and Provision Dealer in the world is going to open at 40 Westgate Street. The fixtures, utensils and fittings will cost over £300. (Thomas Lipton's).

 1893.

1st January. Set in with a fall of snow and continued snowing for a fortnight off and on.

7th January. 1st 'COMET' paper published in Ipswich, the paper is lively, instructive and amusing. It offers large prizes to its readers. It is only 1d.

4th February. I have received a rise in Wages today 9/- per week.

6th February. Mr A. Damart a chemist living at corner of Butter Market, committed suicide by shooting himself at his Father's house at Helmingham on Sunday Feb. 3rd.

10 February. Mr Ernest Oakes of the firm of Oakes, Bevan & Co. Bankers Stowmarket, shot himself after having a rough with his father. It has been very windy lately.

12 February. Sunday. Went to hear the Evangelist Smith of Rochdale at the Wesleyan Chapel, Pitcairn Road.

20 February. Stated the Ipswich Public Baths are going to pull down the existing buildings . . .

4-9 March. Have been tracing off the plans for the new Ipswich Public Baths. They are a bother.

5 March. At the Ipswich Assizes last Monday a very amusing case came before Baron Pollock in the Rector of Claydon and his ditch affair. One of the witnesses was Mr Dickens son of the celebrated Chas. Dickens . . . A new form of taking the oath cropped up at the assizes, medical men objecting to kissing the book, on the grounds that infection was likely to spread therefrom.

11 March. Jackson who claims to be the largest retailer of butter in the world has opened a paltry little shop here. . .

1 April. Nacton Heath is I think on fire, I could see the smoke as I stood in Crown Street today . . . supposed to have been set on fire from a spark from a passing engine on the Felixstowe Railways.

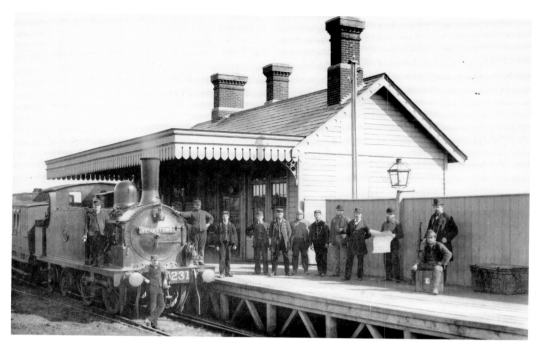

FELIXSTOWE BEACH STATION

3 April. (Easter Monday) Lovely weather . . . to Harwich by boat . . . nearly crushed to dead [*sic*] . . . upwards of 500 persons . . . Went into the Camera Obscure . . . 800 people took tickets from Ipswich to Harwich etc. by boat . . . over 1,000 by train to Felixstowe. Athletic Sports were well attended at Ipswich. Another terrible affair on the Bramford Road here, it must be a bad place and a lot of terrible people live in it. Last October a man was murdered on the Beaconsfield Road . . . Startling discovery about three weeks ago a dead body of a man discovered under a bed where it is supposed to have lain for three weeks in Victoria Street . . . and now about two minutes walk from the last named place a man was killed . . .

Easter Tuesday. A horse tamer on the market, he will tame a man-eating stallion free of charge if you take one to him.

7 April. About midnight an exciting fire broke out in Messrs. Warren & Sons, Hay Stores, Lower Orwell St . . .

10 April. This is my birthday. I am 17 years old today.

19 April. Extraordinary weather, warm, sunshine, and beautiful glorious weather. There has been a demonstration to protest against the Home Rule Bill.

21 April. Race Day. Crowds of people, several 4 in Hands, a wheel came off one at corner of Museum Street, a lot of soldiers from Colchester. Reported man killed and one jockey thrown and cut his eye nearly out.

Thursday. Our soldiers (artillery) have left the town today . . . so we shall not have their old gun carriages lumbering about the town . . . It is reported that Miss Meyrick made a determined attempt at suicide . . .

28 April. About 1 p.m. last Saturday afternoon James Lambert, shoemaker aged 73, living at Crown Street, committed suicide by cutting his throat with a razor . . .

A very sad accident occurred at Bungay Station a few days back. A young porter by name F Skipper was assisting to shunt some trucks he was knocked down and run over, he had been married barely a year . . . Mr Rider Haggard's father has recently died . . .

1 May. There has been a robbing at St Peter's Church, Ipswich and the identification of the man was brought about in the following curious manner. A P. Constable picked up a piece of a broken trouser button outside St

Peter's Church window on the morning of the robbery, and a man was sentenced to 7 days for begging and then it was noticed that one of his trousers button was broken and a further exam showed that the broken piece fitted with the other so well as to leave no doubt but what he was the man . . . There is a grand fancy fair on the Bramford Road, a whole meadow full & 6 splendid arc electric lamps equal to 60,000 candle power. A man aged 54 has been found drowned on the tow-path of the Gipping supposed to be a case of suicide.

6 May. Lovely weather. I have been on a visit to Barham Workhouse . . . to measure up some work there. The master showed us about, it is a down fallen place, but very clean, the long dining halls are brick floor and plain deal dressers with a form on each side and whitewashed walls. The washing room, drying room, bath room etc. are all plain brick floor places. There are some funny looking poor old people in there. The receiving wards are not very desirable places, consisting of a few beds and a bath in sort of out places.

10 May. It is 80 years since we had such a dry month of April as we have had this year. There have been 39 people interred in Ipswich cemetery during the past week.

17 May. Murder by an Ipswich woman. A woman named Suckling took her two children for a walk to Belstead, a little girl about 9 and a boy. She tried to strangle the boy and afterwards cut its throat. She was seen by a man who at once made it known and the woman was arrested and the child taken to Ipswich Hospital where it died soon after admission. She is supposed to be insane and is the wife of a labourer living at 50 Station Street, Stoke. There was a tempest tonight and a good shower of rain . . .

19 May. The *Suffolk Times* and *Mercury & East Anglian Daily* Times are now printed by new fast-web printing machinery.

12 August. Our workmen had their first annual outing at Yarmouth and I went with them.

22 August. Ipswich Lamb Fair and large consignment of lambs etc. a large fancy fair on the Bramford Road. The heat has been very intense for the last few days . . . fires have broke out . . . numerous deaths have occurred from sunstroke.

9 September. I have been appointed agent or secretary to H. Samuel's British Secretaries Watch Club.

10 September. There have been three fires this day in Ipswich.

12 September. The professional runner W. Whale bet £15 he could run from Hoxton Adam and Eve to the Duke of York Hotel, Yarmouth, a distance of 126 miles I think. He stopped at the Barley Mow Tavern, Westgate St for the night.

13 September. Whale started at 11 a.m. for Yarmouth via St Helens, Spring Road, Woodbridge etc.

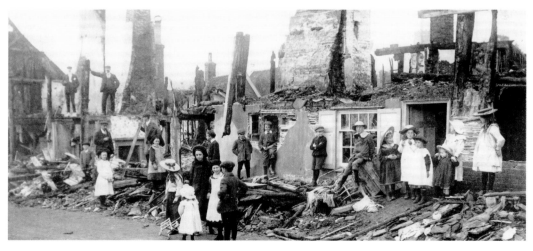

FIRE DAMAGE AT FRAMLINGHAM

14 September. Whale lost his bet, getting into Yarmouth 2hrs late.

20 September. Sangers circus is at Ipswich tonight . . . One of the lions were choked to death while being fed this afternoon . . . I am now in a position to supply thro the manufacturers Watches, clocks, Pianos, bicycles, perambulators, furniture, toys and nearly everything else.

30 September. I went to Poole's Myriorama at the Public Hall.

1st October. Went to Harvest Thanksgiving at Clarkson St Chapel, Rogers the coloured evangelical preacher preached, he said he was engaged up to March 1895.

15 October. (Sunday) Went to hear Rogers the coloured preacher at Clarkson St Chapel. . . He speaks, sings, prays all in good earnest.

16 October. Rogers gave a lecture . . . on 'The Wedding Ring' When to wear it. Who to wear it. How to wear it.

17 October. Joined the Ipswich Victoria Free Library.

3 November. Had a rough with one of our carpenters because I would not pay him what he wanted, he swore at me, and kicked up a rough. We had to fetch Police C. Holmes alias Pratt to quiet him and set him going.

18 November. I took the money to pay the men at Ipswich Public Baths which we are building . . .

28 November. I received a sample of Dalu Rola Tea, tis a very fine tea, I like it much. Very rough, wet and windy night.

7 December. We had a rough at our office with 2 discharged men and I had to go and fetch a policeman, this made the fifty policeman our firm has employed during the last 6 weeks. Surely we must be a quarrelsome lot. The Sudbury Savings Bank manager has decamped with a large amount of money deficient at the Bank.

8 December. There has been a robbery from the London to Yarmouth mail bag. an Ips. railway porter has been arrested, he having cashed some of the missing notes in Ipswich.

18 December. I went to Ips. Fat Cattle Show.

20 December. A wet and nasty day, we are nearing Christmas and the butchers are making a great show of beef, etc. & turkeys all along on dressers in the gutters. The shop windows are very gaily decorated.

24 December. Sunday before Xmas, went to two services.

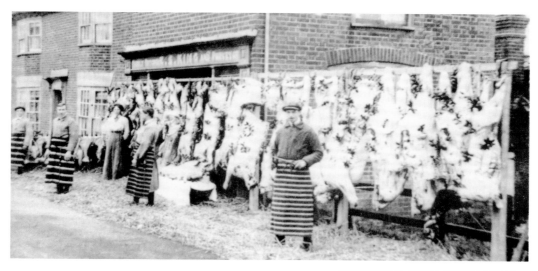

BUTCHER'S SHOP AT WANGFORD

1895.

1 February. In Ipswich it is estimated there has been 700 men out of employment for several weeks past. . .

2 February. I do not think I ever had so many small amounts to pay out in wages as I have paid today. One poor old man had only 3d to take, and many 2/-, 3/- or 4/6. This has been a very trying week for a good many [very bad weather and much snow at this time].

12 February. Water carts are going about giving water to people whose pipes and taps are frozen. Very bad conditions, skating 'carnivals'.

13 February. Made out £3-400 for Town Relief.

17 February. Saw skating on River Gipping—several skated from Ipswich to Stowmarket.

10 March. Informed that 2 boys 10 and 12 who broke into a clothing store recently were in court. 10 was sent to reformatory for 4 years, 12 was given 12 strokes with the birch rod.

24 March. A very terrible gale. . . An iron church was blown down just before the service at Mildenhall.

1 April. A military Sergeant at Barracks shot a fellow Sergeant.

12 May. Weather so cold that brickmakers had to stop making bricks at the brickyard.

? September. Open meeting of British Association (at Ipswich) About 1,300 including scientists from all over the world.

24 September. I have been working on a big estimate for building a new Bank and Residence at Woodbridge for £3,080.

14 October. Paderewski the greatest musician gave a musical recital at the Public Hall. There was about 100 cabs lining the Streets all around the hall.

? October. Lady footballers came to Portman Road ground. . . Hundreds of people to see them. 1st Ladies Match ever in Ipswich.

? October. Telephone is being laid on in Office. . . Diptheria is very bad at St John's, five children were dead in one house.

Philip Thompson

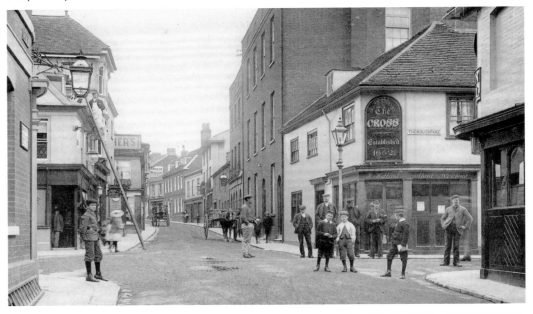

CROSS CORNER, WOODBRIDGE

BUNGAY RACES

This was the second day of the Bungay Races, but I was only in time for the last three events. About provincial race-meetings there are many opinions, and my own, as a non-racing man, is rather against them. To begin with, they encourage gambling; and as a person who has lost hard-earned money in various sporting ventures, though not on horses, my attitude towards gambling is, theoretically at any rate, severe. Apart from joking, there is no doubt that betting does an immense amount of mischief—let those who doubt it walk down the Strand and watch the news-boys on the afternoon of any race-meeting—especially to novices who are so unfortunate as to be successful in their first essay. All who enter upon this field should pray for failure. I remember a story that my late father used to tell me of how when he was a boy he went to the Bath racecourse, and there lost a guinea, which his father had given him, either to a gentleman who manipulated a thimble and three peas, or to a bookmaker—I forget which—and of how, then and there, he made up his mind that it would be the last coin of his which was ever risked in this fashion. Many a man who had won a guinea would have a different tale to tell.

If these meetings encouraged the breeding of good horses, and if the prizes were in the main confined to the owners of animals bred in the district, their desirability, to my mind, would be easier

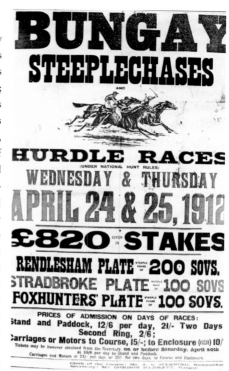

BUNGAY RACES, 1912

to argue; but, in fact, I believe that this is not the case. The racers that appear on these local courses are for the most part second or third class platers which travel from meeting to meeting with their attendant crowd of professional jockeys and white-hatted bookmakers. Against these very experienced persons the astute and horsey gents of the neighbourhood, grooms who have saved a little money and what not, pit themselves, and as a rule come off second best. Indeed, as the late Mr Barney Barnato is reported to have said of the 'sound business man' who thought that he could see through and profit by the financial machinations of the 'Magnates' of the Kaffir Market—'a snowflake in hell fire would have a better chance'. Also, as my own experience shows me, sometimes these 'clever ones' get drunk and lose their situations.

On the other hand, it is urged that race-meetings bring money to a neighbourhood, and afford innocent enjoyment to many country people who make a holiday of the occasion. Without doubt there is much to be said for this view of the case. and I am bound to add, from my experience as a magistrate, that singularly little trouble has arisen at the local races. The worst case which I can remember was that of some welchers who were brought before us on the charge of having defrauded a number of people of their money, one of whom escaped, while his companion, a very smartly dressed gentleman. was convicted and sent to jail for a month. Perhaps the best comment on the undecided state of my mind as to these festivities is that I subscribe a modest sum towards them.

H. Rider Haggard

BUNGAY INNS

A day or two ago the principal hotel in Bungay, called the King's Head, together with another inn in Bridge Street, was put up for public auction. I think that they are the last 'free' houses in the town; that is, houses the occupiers of which are entitled to sell any beer that they or their customers may prefer. All the other houses, and their name is legion, are 'tied' houses; in other words, they have been purchased by various firms of brewers, and are forced to sell the beer made by their owner exclusively, whether it be good, bad, or indifferent. To my mind,

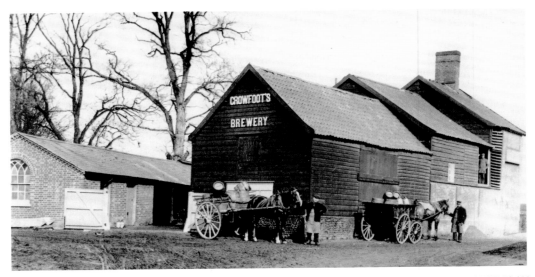

CROWFOOT'S BREWERY, BUNGAY

speaking as the chairman of a bench of magistrates, who has now had a good many years of experience in matters connected with the licensing of public houses, this 'tied' house system is a crying evil. In practice it constitutes a monopoly of the worst sort. The licence granted by the magistrates is nothing more or less than an endowment, which, whatever may be the letter of the law, in fact, as opposed to theory, the bench has little power to refuse. Indeed, any such arbitrary act would be denounced and agitated against as an attempt to offer violence to that god of the English, the Rights of Property, unless it chanced that the management of the house had been reported upon adversely by the police and the licence endorsed by the local bench.

When this happens—and it does not often happen, since for their own sakes the brewers are very careful whom they put in—it is the occupier who is dismissed; the house abides. On such occasions the brewer's agent appears, apologises for the trouble, and announces that the tenant has received notice or been got rid of, whereon the bench has practically no option but to admit any new nominee who can produce decent testimonials. The great value of such an endowment, even in the case of a quiet country town like Bungay, is shown by the fact that not many years ago the local branch of the Oddfellows purchased the King's Head for about 1,800*l*., whereas at the recent auction it was sold for over 6,500*l*., although I believe that the lease of the present tenant of the inn has some years to run, during which time he cannot be forced to sell any particular brand of beer or spirits.

I confess I am unable to understand the advantages of this system, that enables people with long purses to force the public to buy any yellow-coloured liquor which they choose to honour with the name of beer, although, in truth, in some instances it is, I believe, scarcely more than a chemical compound manufactured from I know not what. The only explanation is that, being the wealthiest men and a magnificently organised power in this land, the brewers are careful to stop any legislation which can possibly cut into their great profits.

As a further safeguard, most of them have made their businesses into public companies, in which they retain the controlling interest, thereby converting tens of thousands of small shareholders into their partners and enthusiastic supporters. How vast and dangerous is their strength is well shown by the disaster that overtook the Liberal party when it made a platform plank of Local Option. Looking at this scheme from a practical and not a political point of view, I think, however, that it deserved to fail, because, as it seems to me, it would foster the very thing which I consider such an evil—the indirect endowment of public houses. It is not to be expected that any town in England would vote for the closing of all drinking places within its limits, as sometimes happens in America, nor will most people consider it desirable that this should be done. Therefore it is probable that what might happen is that a certain proportion of the houses would be penalised by a popular vote, while the value of others which escaped would be enormously enhanced. Nobody can be more convinced than I am that there are far too many public houses; in Bungay, for instance—I think that I once reckoned in the course of a disputed

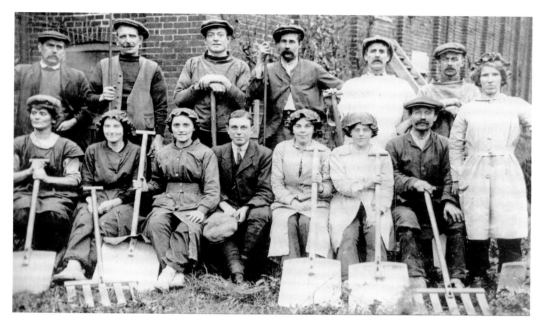

WORKERS AT WAINFORD MALTINGS, BUNGAY

licensing case—there is a liquor shop of one kind or another for every 100 of the total population. Yet as the people love to have it so, it seems impossible to escape the evil. Now, to make matters worse, the houses, or rather the licences, have been bought up by the brewers and turned into a close monopoly.

H. Rider Haggard

BREWSTER'S SESSIONS

September 1.—Today we held our Brewster's Sessions at Bungay when, as no complaints were made, all the licences were renewed. According to the calculation of the superintendent of police there is in Bungay a licensed house to every 106 of the population, infants in arms included, and this without reckoning the wine-merchants or the establishments which trade in alcoholic liquors by virtue of what are known as 'grocers' licences'. In the parishes of the district things are little better, for here there is a licensed house to every 207 of the population. It will be observed that in Bungay and its neighbourhood the toper need not go thirsty for lack of opportunity to quench his drought.

The superintendent also read his report for the year on the crime statistics of the district. I am glad to say that they show a marked and progressive diminution, owing chiefly, I believe, to the spread of education among the classes from which spring the majority of criminals. For instance, I can remember that when first I served upon this Bench we were often called upon to deal with charges of brutal assault, cases in which people had been got down and kicked or knocked about with heavy sticks, and so forth. Now we have but few of these offences, a fact that cannot be attributed solely to the measures which we took to put a stop to crimes against the person.

H. Rider Haggard

BUNGAY COMPOST

Today two carts are carrying refuse from the undrained town of Bungay to be scattered on that part of the nine acres of land, No. 23, which is coming for root, or on so much of it as we can spare time and horses to cover. We have been at the task for nearly a week, sometimes with two and sometimes with three carts, and, I think, have spread about fifty loads upon the root land. This compost, disagreeable as it is in many ways and mixed with troublesome stuff, such as old tins and broken glass, is the best manure which I have ever used; but I think that

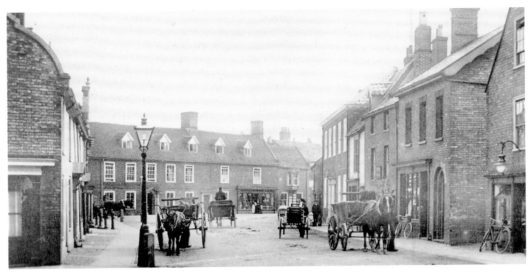

EARSHAM STREET, BUNGAY

to get its full value it should be spread upon the land and ploughed in at once, leaving it to decompose beneath the surface. I adopted this plan last year on the piece of rootland at All Hallows Farm, No. 33, and with the most excellent results. The field is small, but, notwithstanding the drought, the piece of beet which resulted was the finest that I have yet grown. The cost of this manure is about two shillings the load as it lies upon the heap, and I suppose that the carting would come to as much more. Against this expense, however, it must be remembered that it spares the farmyard, upon which the calls are heavy and continuous; also for a root crop I would rather use it than any expensive artificial dressing on the market.

H. Rider Haggard

RENT AUDIT DAY

For the benefit of those unacquainted with the function I will describe a rent audit of the local type. The ceremony begins about twelve o'clock, when the agent takes his seat in a small room in the King's Head at Bungay, and makes ready his papers and book of printed receipts. To him presently enters a tenant who produces—or does not produce, as the case may be—the rent he owes. Also in these times he generally takes the opportunity to point out that a further reduction upon the attenuated sum payable is absolutely necessary to enable him to live. In most instances his story is true enough, although the landlord could wish that he would show as great a readiness to call attention to the fact whenever times or prices improve. Such an instance of almost superhuman virtue has just come to my notice. A tenant of a relative of mine in this neighbourhood appeared the other day and paid his rent, plus an extra sum of 9/. Being asked for what the 9/. was owing, he answered that when he took the farm he came to a verbal understanding with its owner, since deceased, that if ever times improved, his rent should be increased. There was no written statement to this effect, and the other party to the arrangement can no longer bear witness to it; but as this pearl among tenants considered that times had improved with

H. RIDER HAGGARD

him to the exact extent of 9/., he handed over that amount unasked. 'Comment is superfluous.'

In the old days it was customary to discharge the rent in coin, a practice which some tenants still keep up, but now most of them have a banking account and pay by cheque. From the sum due is deducted the amount disbursed out of pocket by the tenant, but properly chargeable to the landlord, on account of rates and taxes or repairs. Then the cheque is drawn out, often slowly and with labour, unless, indeed, it has been brought ready prepared, in which case the agent gives a cross cheque for the difference, plus any allowance that may have been agreed upon. Next, having been offered and drunk a glass of sherry, that tenant departs with a sense of duty done, a lighter pocket, and the instruction to send up Mr So-and-so.

Of course there are tenants and tenants. There is the spacious and horsey young man with a glib tongue, from which flow reasons innumerable why he should not pay his just debts, or plausible explanations as to how he came to be found selling straw off the farm. This sort is at one end of the scale. At the other stands the silver-haired old gentleman who has been a tenant on the estate for fifty years, and all that time has never failed to meet his rent. To such a one to 'get behind' is a real grief, indeed I have seen a man of this stamp almost break into tears because the times had at last proved too much for him. The most remarkable tenant that ever I had to do with, however, was an old gentleman, now dead, who had occupied a farm belonging to this estate for no less than seventy-seven years. The time seems long, but he was born in a certain room in that homestead, for seventy-seven years he slept every night of his life in the room, and there finally he died. He was a man who drove about the country a good deal to markets and other places, but, at any rate during the latter part of his life, no earthly consideration would have induced him to be away from home for a single night. Indeed, the dread of such a thing obtained a complete mastery of his mind, and I believe that on one or two occasions, when accident detained him at a distance, he spared no expense, and journeyed incessantly to reach his farm before the following dawn. In these days of frequent and distant travel it is certainly curious to hear of a man of some position who has slept in a single house for seventy-seven years, but among the lower classes such cases are not exceptional. Thus, a few years ago, one day when I chanced to be at a village called Spexhall, about six miles from Bungay, where I have a farm, I lost my way in a lane and asked a labouring man to show it to me. He proved almost as uncertain about it as I was myself, which puzzled me till I discovered that, although he must have been sixty years old and had lived in Spexhall all his life, he had never yet visited Bungay, a few miles from his door.

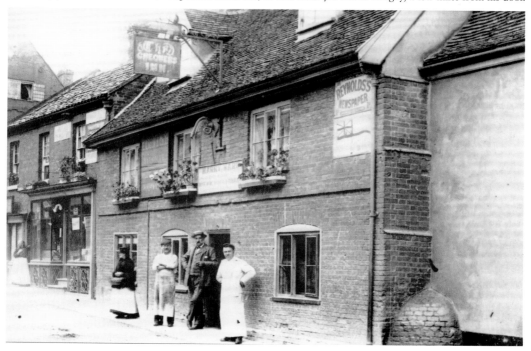

CHEQUERS INN, BUNGAY

When the tenants have been interviewed, or most of them, dinner is announced, about three o'clock generally, and everybody adjourns to a long, old-fashioned room. Here the landlord takes the head of the table, and the agent the foot, while the tenants range themselves in solemn lines on either side, in order of seniority and social precedence. Then grace is said and the meal begins; and an excellent meal it is, by the way, though perhaps it would not recommend itself to the guests at a London dinner party. Here is the menu, which never varies from year to year:

<div align="center">

Clear Ox-tail Soup.

Fried Soles. Boiled Cod.

Roast Beef. Boiled Mutton.

Chicken and Tongue.

Roast Turkey.

(For this festival is always celebrated early in January.)

Plum Pudding. Mince Pies.

Cheese.

Beer, Port, and Sherry.

</div>

Such is the feast, most admirably cooked in the good old English fashion with the old English accessories, and it is one to which hungry men who have eaten nothing since the morning certainly do justice.

H. Rider Haggard

THE LAND

Suffolk is classified as a corn county, that is, a county in which the acreage under corn is two-thirds more than the acreage under permanent pasture. Its agriculture consists almost entirely of corn growing, sheep breeding and feeding, and winter grazing or feeding of cattle. The soil varies from light gravel or sand on the east coast, to stiff clay in the centre of the county, 'High Suffolk' as it is called (where no one will own to living), and some chalk on the western border. The four-course system of farming is almost universally adopted, coupled with restrictions against the sale of hay, straw and roots off the farm. Rents in 1880 ranged from 7s 6d an acre for very light sandy soil, to 40s an acre for good mixed soil farms, and 42s for best marsh grazing land. The cottages, as elsewhere, are fairly good on the large estates, very bad in the 'open' villages, where they are in the hands of small proprietors.

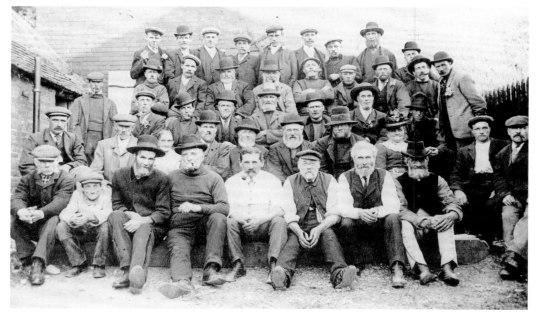

WESTLETON

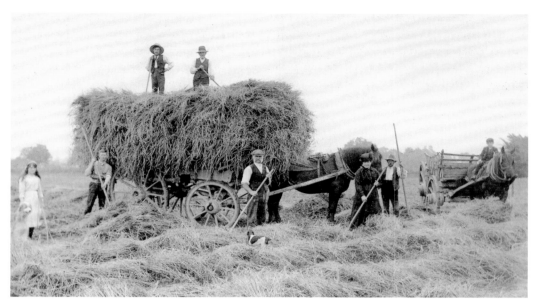

WHITEHOUSE FARM, HARLESTON

Villages are, however, the exception rather than the rule in Suffolk, the cottages being generally scattered about the parish.

Report on Suffolk Agriculture presented to Her Majesty's Commissioners by Mr Drace, from Quarterly Review no. 328, April 1887

CHILDREN ON THE LAND (1)

A very large number of children are employed at farm labour in this county. Both sexes are sent to the fields early in life to add to the scanty income of the family. John Pearson Esq., of Framlingham, says: 'Every person in the parish employ children in crow-keeping. I dare say at one time we had fifty or sixty children employed in crow-keeping.' In Hartismere, Hoxne, Woodbridge, Plomesgate and Blything Unions, children are very generally employed.

Much depends on the size of the child and the necessities of the family as to the age at which *boys* are first employed, but as a proof of the tender age at which work is commenced in this counry, we name that at Mildenhall the witness said, 'In some places (in summer) they begin as early as six years of age.' A gentleman at Wickhambrook observes, 'At the age of seven and upwards they go bird-keeping and picking weeds off the land: Mr Moore of Badley said, 'Boys sometimes come at 2d a day; little things that can hardly walk come with their fathers,' and Mr Lane of Framlingham testified that children sometimes go to work at six years of age, they usually go at seven. In many districts, however, nine and ten years of age are the most common to commence work.

The kind of work in which they are engaged varies in different districts. They are generally engaged in weeding, corn-dropping, pulling turnips, crow-keeping and assist

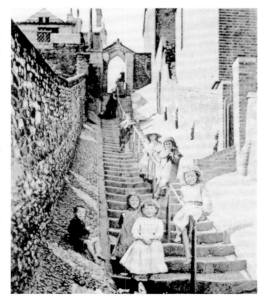

SCORE AT LOWESTOFT

in stone-picking, and, except in cases of scrofulous children, injurious effects on the health or constitution of children are seldom observed. In some parts however, they are employed in carting, doing man's work instead of boy's, attending horses with heavy tumbrils, and their lives are thus frequently endangered. The danger there is in this employment is thus depicted by an eye-witness. 'If you lived in the country, as I do, you would sometimes see a sight which would make your blood run cold, and yet it is so common a sight that we country people grow accustomed to it. You would see a great lumbering tumbril, weighing a ton or two, with wheels nearly six feet high, loaded with manure, drawn by a great Suffolk cart horse as big as an elephant, and conducted by a tiny thing of a boy who can hardly reach the horses's nose to take hold of the rein, and if he can, has neither strength nor weight to make such a huge monster feel, much less obey.'

John Glyde Junior, Suffolk in the Nineteenth Century

CHILDREN ON THE LAND (2)

A good insight into the out-door work and living is afforded by the following statement:

Hannah Winkup, servant to Mr Catt, of Whitton. I am 15 years old—was born at Sibton, near Yoxford. My father was a blacksmith; my mother had twelve children, and one of them was deaf and dumb; went out to work in the fields when I was 12—keeping birds, sheep or cows; I frequently done boy's work—keeping sheep or cows to prevent their getting into corn fields. I had 3d a day; worked Sunday as well, but my master used to give me a dinner on Sunday. Have gone stone-picking, hay-making, weeding and dropping. Earnt 5d a day at dropping; like hay-making best. Stone-picking is the hardest work I done—so much ligging; the stones have frequently to be brought from top to bottom of the field and it is very cold work. I worked from eight o'clock in the morning to six o'clock in the evening. Got my breakfast before I went; was allowed one hour for dinner, from twelve to one; had no more until I went home at six. I had bread and cheese for breakfast and cold coffee, no sugar—same for dinner, and very often the same for supper. At other times mother would boil a dumpling for us for supper, this was in stone-picking time, when we always come home very cold. We were so poor that sometimes I have had to go to bed without a supper; generally had a piece of meat on Sundays not butcher's meat, but pork. Have been in service three quarters of a year; my mistress is very kind to me; she lived in the same village as I did; I have £2 10s a year wages, and Missus gave me clothes worth another pound.

John Glyde Junior, Suffolk in the Nineteenth Century

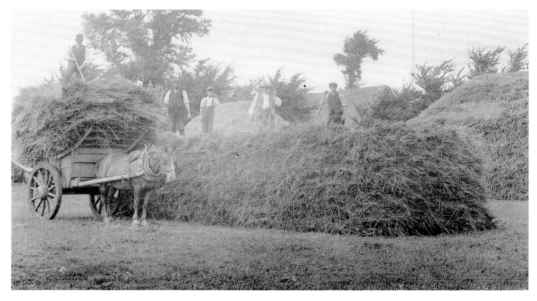

HARVEST AT WETHINGSETT

HARD TIMES IN FARMING

Now when the hard times came the wiser men weathered the storm while the unwise were wrecked. The former had been saving money during the good years and could draw on their bank balances. They had lived quietly and so needed to make little change in their home budget, and they had not more land to farm than they could attend to well. With lower rents and extra care they managed to make both ends meet. One new thing many of them now began: namely, the keeping of accounts. Formerly their bank passbooks were the sole record they possessed, and not one in ten had the foggiest notion of whether the corn or the cattle or the poultry were each paying their way.

The fat cattle were usually sold to the butcher 'as they stood'. When the farmer asked what he wished to get and the butcher replied that 'he would give him some of it', the butcher was generally successful in the bargain. Now came the change. The price was fixed at so much per pound 'dead weight', and so the seller was safer from losing money on his beast. I was told by a very able lady who had a chief share in the management of a farm from about 1880 to 1890, that

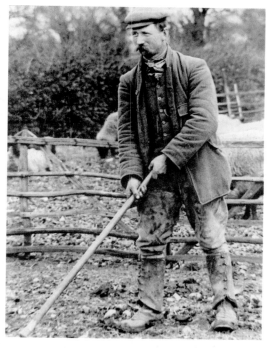

SHEPHERD LIFTING ORTS, PLAYFORD

everything, including the eggs, was accounted for, and to that she attributed their success. Economy, careful attention, and the keeping of accounts pulled them through many hard years. The personal factor in success comes to the fore when difficulties and changes arise in agriculture, and this was shown in the fact that every here and there a man was able to increase the area that he farmed with profit. There was more than one man in our district who succeeded in this way. How he did it is not easy to say, but the following is an attempt at explanation. If there be four men in the parish all quite competent to carry on one farm each, not more than

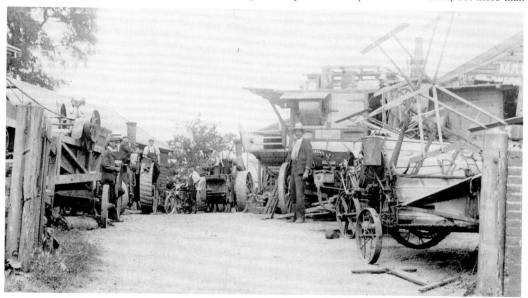

FARM AT WALSHAM LE WILLOWS

one of them will have the character and ability to succeed with two farms, and as for running three farms at a time, I should say that not one man in ten can do it. The reasons for this limitation of capacity are that agriculture needs such varied knowledge of the soil and the way every field should be treated; and also of the horses, cows, young cattle growing up, larger beasts being fatted, pigs and poultry and sheep—'things that eat and die', as a man said who declined to invest money in any kind of livestock. The welfare of all these depends on the men employed by the farmer, and a little carelessness or stupidity by carter or cowman may mean a horse lamed or a cow dead. So no farmer can hope to succeed unless he chooses his men aright and retains their goodwill, and they have little respect for him unless he can notice quickly whether any animal on the farm is not looking as it should.

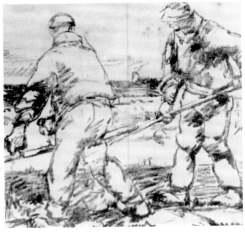

REAPING WITH SCYTHES

When a man has one farm it is not hard for him to see every animal once a day, and also to look how the work is going forward which he had planned out in the morning, but if he has to move away for a mile or more to a second farm, the claims on his attention are double, and he may find that two and two make five. Yet, as I said, there are men who come to the front in these hard times, and one of them was rather a friend of mine. He was a very handsome little man, rough of speech, and not well educated. 'I never could make much hand of spelling,' he said, 'and I used to think that would be a hindrance in business—making out cheques and so on—but it don't make much difference. A man will allers tell me how to spell his name.' His theory of how to farm he stated thus. 'Folks say I ought to work on the land. Well I won't. If my head can't keep me then my hands can't.' There were men of that calibre all over England who, during the long years of depression, were able to take over farms which were vacant and work them with success, but I think that all of them would agree with my Debenham friend that it must be their head, not their hands, which should do the work.

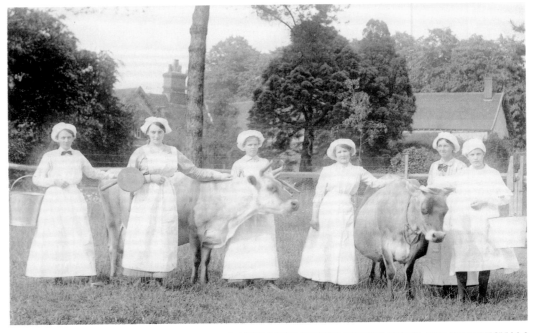

DAIRY MAIDS WITH JERSEY COWS AT MENDLESHAM

In the eighties the first large experiment in co-operation among farmers in Suffolk was initiated and carried through with success: the collecting and marketing of eggs, first in the Framlingham district and then over a wide area.

James Cornish

EGG STEALING

Today at the Bench we tried one of the egg-stealing cases which are always plentiful at this time of year. The defendant, a 'marine dealer', was accused of sending a box of 251 partridge eggs ('twenty dozen smalls, eleven reds', i.e. French partridge, according to his own invoice found in the box) to another 'marine dealer' in a neighbouring town. This second gentleman, by the way, was recently fined £21 10s., being 1s. an egg, for 630 stolen eggs. The case against the defendant today was clear, and he also was fined 1s. an egg and costs, with the alternative of two months in prison.

H. Rider Haggard

ASSINGTON AGRICULTURAL ASSOCIATION

At Assington Sir Brampton Gurdon, MP very kindly showed me over Severals Farm and another small farm adjoining, which are rented by the Assington Agricultural Association and belong, I believe, to Sir Brampton himself. This farm is run by a company of labourers and managed by a local committee of working men. The original capital, I think, was advanced by one of Sir Brampton Gurdon's predecessors without interest, and the venture has received other support from philanthropists. The accounts that I have at hand are a little difficult to follow, and in April 1891 there seems to have been a bank overdraft of £153; but I gathered that the enterprise was moderately successful and had met with a considerable measure of local encouragement. The rent charged against the land, which is worked by labourers to whom the ordinary wage is paid, is 10s. the acre, the farm being managed by the local committee. On the whole the land was in good order and well stocked. That this is a useful experiment there can be no doubt; but however it is managed, to make money out of a Suffolk holding of this character is not easy. A good many poultry were kept upon the place, together with stock, and on the adjoining Notts Farm, six cows, of which the milk was sold in the village, and about fifty pigs.

H. Rider Haggard

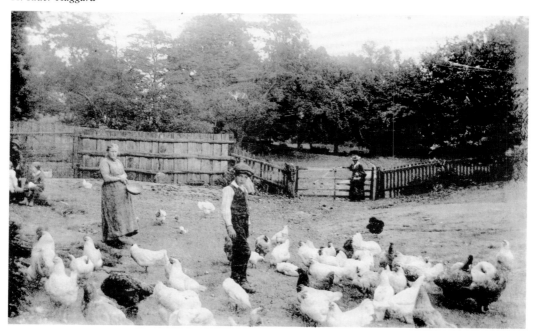

POULTRY AT WALDRINGFIELD

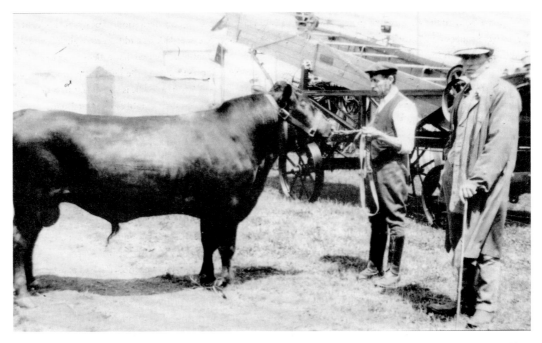

RED POLL BULL AT THE SUFFOLK SHOW AT GORLESTON

SMALL-HOLDERS

Another smallholding of about twenty acres which we saw in this neighbourhood was held by a man who, Mr Flick told us, had been a labourer ten years before and was now in a position to take a farm of forty acres. These men are samples of the small-holders who live in the neighbourhood of Theberton. None of them were rich, or extraordinarily successful; but it will be observed that on their own showing they all of them made a decent living; also that the majority had risen from very humble beginnings.

Yet in various parts of Suffolk I was told it was almost impossible that small-holders could exist and that they ought to be discouraged in every way. Of course the truth is that their prosperity depends upon the land they farm, although I believe myself that even in the present unpropitious times, there are men who, in the absence of any exceptional ill-luck, will contrive to live upon almost any sort of land, and occasionally even to advance their fortunes. Certainly the little farmers in the neighbourhood cannot be said to possess any remarkable advantages either as regards markets, or in the matter of the production of a speciality only suited to their district. They are general farmers and live out of the produce which is common to the county.

H. Rider Haggard

SENSATIONAL CRIME IN SUFFOLK

A VILLAGE GIRL'S MYSTERIOUS DEATH

In the quiet village of Peasenhall, near Yoxford, Suffolk, a shocking discovery was made in the early hours of Sunday week. At Providence House, a substantial detached residence, lived an aged couple named Crisp and a brother of the occupier. Only one domestic servant was kept, a young woman of twenty-three, named Rose Harsent. The whole household retired to rest as usual on Saturday night. About eight o'clock on Sunday morning the father of Rose went, as was his custom, to carry clean clothes to the girl, and was surprised to find the vinery door open. Walking through he saw the kitchen in semi-darkness, through something being hung before the window. On discovering the dead body of his daughter Mr Harsent at once raised an alarm, and Mr E. Crisp came downstairs. The police were then communicated with, and a search commenced.

When the body of the victim came to be examined the case was regarded as very mysterious. For a time accidental causes were suggested as possible, but on closer investigation these were discarded. In addition to frightful wounds in the throat, both hands were found to be fearfully cut inside, the thumb of the left hand being most severely injured. This is held to point to there having been a terrific struggle. Some doubts on the part of the medical man who was called in were removed when a relative told him that the girl was left-handed. It is significant that no knife or sharp weapon was found in the kitchen, though it is believed that the victim was stabbed in a vital part.

The girl Rose had been in her situation for three years, and it appears became engaged to a young farm labourer, who was deeply attached to her. They went to the same Primitive Methodist chapel, and attended the Sunday school. Knowing that she was fond of music and that she was anxious to learn to play, he bought her an American organ, for which he paid. Preparations were also begun for furnishing a home, but about a year ago a scandal arose in consequence of it being openly stated that Rose had been seen under suspicious circumstances with another man. This was at what is locally known as the 'Doctor's Chapel'. Both the girl and the man denied that there was any cause for complaint, but the affair led to a rupture between the lovers. When reproached by a relative, who asked:

'Rose, why are you treating Robert in this manner?' the girl replied, 'Oh, he's too quiet for me; he has never anything to say. I like a man that's got some life in him.'

Nevertheless, Rose was described as a nice, cheerful girl that anyone could like. On the whole she had proved a good servant. Her appearance had of late led to suspicions regarding her condition, and friends had earnestly begged her to confide in them; but to one and all she most positively denied that there was anything the matter with her. It was known to a few that she was preparing to go to Yarmouth shortly, and the reason of this is now apparent, inasmuch as she was within a very short time of her confinement. When a relative reminded her that the anniversary of the chapel would be on June 15 Rose said she should not be there this year. The ease with which the girl could receive secret visitors is explained by the fact that her room was reached by a separate staircase from that used by her mistress.

In the very early hours of the Sunday morning, possibly while the murder was being committed, there was a severe thunderstorm in the district, and it is thought this may have prevented any cries of the girl being heard. That an attempt was made to conceal the crime by setting fire to the house is considered certain. The body was shockingly burnt on both sides, especially under the arms. A broken armchair and the kitchen table also bore marks of fire, but they had failed to blaze up. The paraffin lamp had been placed in a position where it might have exploded, but this happily did not take place, otherwise the whole house would have been in imminent peril. The inhabitants indeed are impressed with the fact that in Providence House they have had a very special Providential deliverance from a great danger.

The dreadful news spread rapidly throughout the district, and was received with deep emotion in the chapel which the poor victim usually attended. There the service was partially conducted by Mr William Gardiner. After giving out two hymns he asked the young farm labourer Robert to announce the third, which he did. Gardiner then went

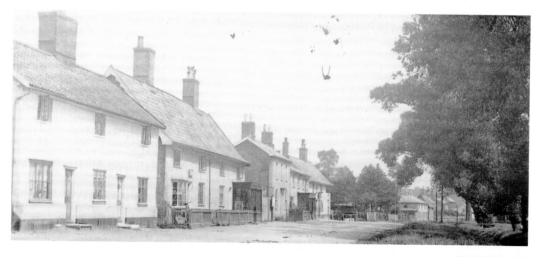

PEASENHALL

into the pulpit and finished the service.

At the opening of the inquest on Tuesday, the first witness was the deceased's father, William Harsent. He had been, he said, in the habit of visiting his daughter every Sunday to carry her clean linen. Last Sunday he went as usual about eight a.m., and found her lying on the floor, her head surrounded by blood from jagged wounds in her neck, and her nightdress partly burned off her body.

Mrs Crisp, who was next called, stated neither she nor her husband went into the kitchen, but she shut the door leading from the kitchen into the dining room.

'Did you not hear any cries for help?', queried the coroner.

Witness replied she thought she heard a thud, followed by screams, about an hour later. She remarked to her husband, who is very deaf, 'I wonder if Rose is nervous. Shall I go to her?' He responded, 'No. If she's nervous, she'll come to us.'

Further questioned, witness said she saw no light in the girl's bedroom, and she could not account for the rug being hung over the kitchen window.

Police constable Nunn described how he found a bracket on a shelf broken, which might have been caused by the kitchen door being forced back. In deceased's bedroom he found the following unsigned letter on the lid of a box:

ROSE HARSENT

'Dear—, I will try to see you tonight at twelve o'clock at your place if you put a light in your window at ten o'clock for about ten minutes, then you can take it out again. Don't have a light in your room at twelve, as I will come round to the back.'

Dr Lay expressed the opinion that the burns on the deceased's body did not cause death. A broken lamp was by her side.

The Coroner: 'Do you think the wounds on the neck could have been inflicted by broken glass?'

Witness: 'I think it is possible the fleshy part of the wounds might.'

'Then the inference is that the whole of the wounds could not have been done so?'

'That is so.'

'Were the wounds self-inflicted?'

'I cannot give a definite opinion yet.'

The inquiry was adjourned till Monday, June 16.

The Illustrated Police News, *14 June 1902*

SUFFOLK RECTOR DEPRIVED OF HIS LIVING

Mr Cadge of Loddon, appeared on behalf of Mrs Eleanor Mary Hotson, one of the patrons of the benefice of Thwaite St John, Suffolk, to prosecute the Revd Allen Zachariah Grace, rector of Thwaite St John's, for a serious offence under Section 2 of the Clergy Discipline Act. The defendant, who was thrice called, did not appear.

Formal evidence was given that defendant was instituted to the living on May 1st, 1888, and that on July 1 last he was convicted. . . of having stolen wearing apparel. . . and sentenced to six months' imprisonment. . .

Dr Bensley, the registrar, then proved that on September 28, 1889, the defendant was suspended by the court for three years for drunkenness and until he furnished testimonials in the ordinary form. The testimonials had never been forthcoming. . .

The Suffolk Chronicle, *8 February 1896*

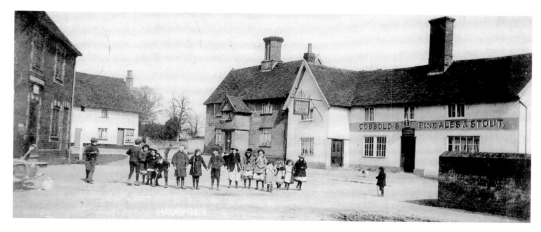

HAUGHLEY

MURDEROUS ATTACK ON A WOMAN AT HAUGHLEY

On Monday morning at about eleven-o-clock, a man named Walter Miles, a desperate character, made a murderous attack upon Laura Miles, the wife of Geo. Miles, labourer, living at Tot Hill, Haughley. It appeared that Walter Miles had been served with a summons to appear before the Stowmarket Magistrates on Monday, to answer a charge of threatening Mrs Miles and other members of the family. When the constable served the summons Miles had a cutlass in his hand, which was thought to be for the purpose of resisting any attempt that might be made to convey him there and then to the Police-station. He did not appear at the sitting on Monday, and an application was made for his apprehension, when Inspector Phillipps received information that the man had attacked the unfortunate woman and inflicted most serious injuries upon her. It seems. . . Mrs Miles was in the backyard and saw Walter Miles entering the gate, armed with the cutlass. . . she ran down the yard screaming and got as far as a meadow when Miles. . . overtook her and commenced to strike her furiously with the weapon. . . . His first violent blow fell on the back of her head, she instinctively tried to shield her face with one arm; the force of the next blow broke it, and her other arm was lacerated by a terrible cut. She also received other cuts about the face, head and arms. Mrs Hannibal, a neighbour. . . went to her rescue, and Miles threatened to kill her. Fortunately a man named Turner was attracted by the screams to the spot. . . Miles ran off. . .

The Suffolk Chronicle, *1 February 1896*

PEASENHALL MURDER RE-TRIAL

ADDITIONAL EVIDENCE FOR THE DEFENCE

The re-trial of William Gardiner, foreman carpenter, on the charge of murdering Rose Anne Harsent, a domestic servant, at Providence House, Peasenhall, on June 1st, is expected to open on Tuesday next at the County Hall, Ipswich, before Mr Justice Lawrence, and promises to excite even more interest than did the first trial. The prosecution have not signified any intention of calling additional evidence, so it may be assumed that sole reliance will be placed upon that already given. On the other hand those responsible for the defence have left no stone unturned to procure fresh witnesses and at least ten more will come up to speak in the prisoner's favour. Their evidence, it is understood, will be mainly directed to contradicting many points which were put forward at the last hearing by the Treasury as tending to the man's guilt.

In spite of the many rumours to the contrary, Gardiner has borne up bravely in prison, and his health has been good. He has of course been braced up to some extent by the nature of the evidence which will be called for him, and he confidently looks forward to an acquittal. The counsel engaged in the case are as before—Mr Dickens, K.C., and the Hon. J. de Grey, for the Treasury, and Mr Ernest Wild (at Gardiner's special request) with Mr Claughton Scott for the defence. The trial is reckoned to extend over five days.

East Anglian Daily Times, *14 Jan. 1903*

GIPPING

Off to the left hand, in strong contrast with this level stretch of road, the country is tumbled into combes and rounded hills, where the River Gipping takes its rise in the village of that name, springing from the hill where the church tower stands solemn and grim, as though it held inviolate the story of the place, away from those days when the Gippings first settled here and gave it a title.

But let not the hurried seek Gipping, along the winding byroads. The way, if not far, is not easy, and passengers are few. Scattered and infrequent farmhouses there be, at whose back doors to inquire the way, but rustic directions are apt to mislead. In any case, it is little use approaching the front door of a farmhouse. No one will hear you knocking, unless indeed it be a watchful and savage dog, trained to be on the alert for tramps; and you are like to hear him snuffling and gasping on the other side in a ferociously suggestive manner which will render you thankful that the door is closed and bolted. And not only bolted on this occasion, but always. The steps, and the space between the door and the threshold, where stray straws and wind-blown rubbish have collected, are evidence of the fact that the farmer and his family do not use the front door, but make their exits and entrances by way of the kitchen. It is an old East Anglian custom, and although many of the farmers nowadays pretend to culture and set up to be as up-to-date as the retired tradesfolk and small squires they are neighbourly with, many others would no more think of using the principal entrance to their homes than they would make use of the 'parlour', where massive and sombre furniture, covered with antimacassars, is disposed with geometric accuracy around the room, in company with the family Bible and the prizes taken at school by the farmer's children; the stale and stuffy atmosphere proclaiming that this state apartment is only used on rare and solemn occasions. In fact, the 'best room' and the front door only came into use in the old days on the occasion of a funeral. Perhaps it is a custom originating in a laudable idea of paying the greatest possible respect to the dead, but it is one which certainly gives a gruesome mortuary significance to both the entrance and the room.

Charles Harper

OLD FALSE TEETH BOUGHT

Many ladies and gentlemen have by them old or disused false teeth, which might as well be turned into money. Messrs R. D. and J. B. Fraser, of Princes Street, Ipswich (established since 1833), buy old false teeth. If you send your teeth to them they will remit you by return of post the utmost value; or, if preferred, they will make you the best offer, and hold the teeth over for your reply. If reference necessary, apply to Messrs Bacon & Co., bankers, Ipswich.

Bury Free Press, *17 March 1900*

RIVER GIPPING

IPSWICH 1900

Domestic service was plentiful and cheap and income tax was only about one shilling in the pound. There was however much poverty, although a lot of it was hidden. . . At the annual Poor Children's Christmas Dinner about two thousand were packed into the Public Hall and the Corn Exchange. Anonymous local gentlemen saw that the Police Poor Box was never empty and financed a fund, administered by teachers, for providing boots and shoes for needy children. For those who were not members of Friendly Societies there was only Poor Relief in times of sickness and unemployment. The population was sixty-six thousand but increasing by about a thousand a year. Only ten thousand of these were voters. . . Most of the fourteen thousand inhabited houses were crowded together near the centre. Many of them were slums in courts or yards.

The Tramway Company's horse-cars were still running. . . There were also horse-buses, privately owned. . . . The electric trams, with thirty-six double-deck cars and eleven miles of track, opened in 1903, with the new power station in Constantinee Road, and a Refuse Destructor on the same site. The Public Health Department was mainly concerned with insanitary houses and unsound food. There was an Inspector of Nuisance with one assistant. Owners of sub-standard houses were being compelled to provide their properties with a separate water-tap and a proper WC connected with the sewer.

The main shopping and business streets were paved with creosoted wood blocks. Street lighting had been improved. . . but the lamp-lighters with their long poles still made their morning and evening rounds. There were few motor-cars but they were steadily increasing and could now travel at twenty miles per hour. They had no registration, no number plates, and no licensing of cars or drivers until 1903. The carriers were still a valuable means of communication and there were about thirty of these with their days and times set out on Cowell's Monthly Time-tables. The Head Post Office was open until 11 p.m. on week-days and for two hours on Sunday evenings; there were five deliveries of letters on weekdays and one on Sundays. Most food-shops were open until 10 p.m. on Saturdays when some butchers disposed of their unsold stock by Dutch auction.

The Lyceum Theatre had its special Grand and Light Opera and Shakespeare Weeks. There were the Hippodrome, Poole's Myriorama, Tudor's Circus, the Christmas Three-day Show, the Harwich and Felixstowe paddle steamers, the Ipswich Town Amateur Football Club, three breweries, two hundred and sixty public houses, fifty off-licences and a Police Force of only sixty-seven.

E. J. Booty

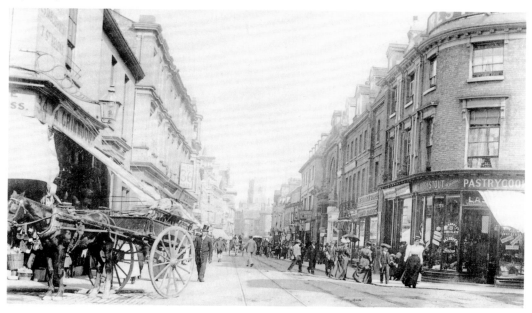

WESTGATE STREET, IPSWICH

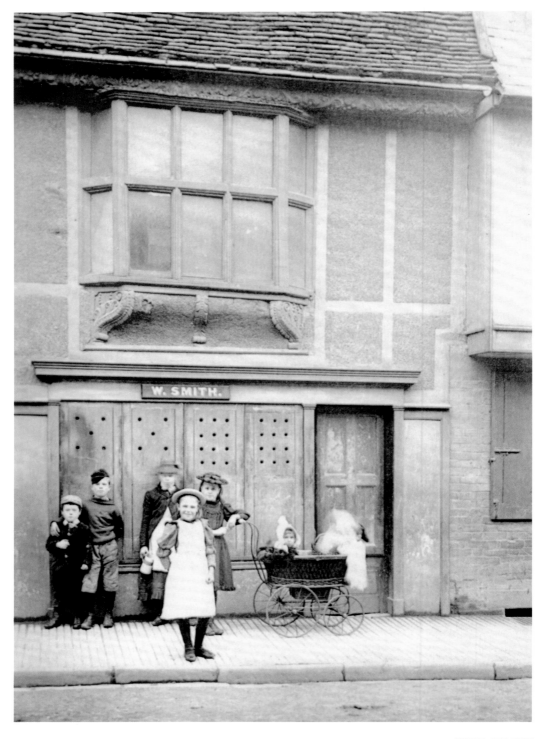

FORE STREET

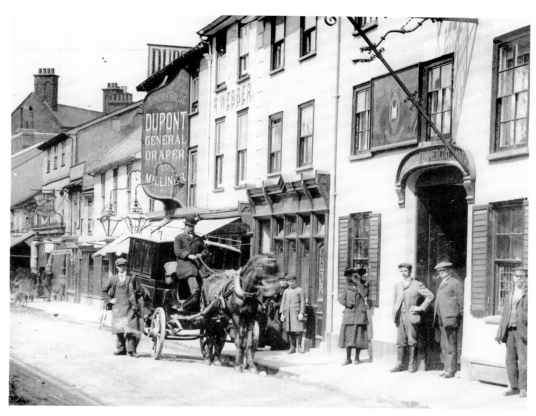

STOWMARKET

SHOPPING

Shops and stores were then heavily stocked with goods, and the larger concerns in the towns were often no better than the small village shop where the odour of paraffin oil and pickled onions permeated everything.

As I said previously, those who were bold to assert that they were anxious to serve 'the quality' were sometimes unmindful of the first essentials of hygiene, while some premises were totally unsuited anyhow to the purposes for which they were used.

At the turn of the century shopping was a personal affair carried out by some with all the leisurely charm of the period. As soon as Her Ladyship's carriage arrived at the business premises, a member of the staff would hurry to open the door and proceed to give the horse a friendly pat. It was all part of an association as between customer and tradesman, the former always being a very important person in the eyes of the latter. The same service ensured that come hail, rain or snow, deliveries were carried out.

The trader 'respectfully solicited' your custom—and exerted every energy to hold it. If you were on his books you always received a calendar at Christmas, a pleasant custom which is not so extensively carried out today. You confided in the shopman and shared his joys and sorrows. It was a happy alliance. He invariably lived on the premises and stabled his horses at the rear.

Those were the days when sawdust was sprinkled on floors, and shop stocks often overflowed to the forecourt of the building. Much of the stock was carried from year to year—particularly in hardware and ironmongery establishments—until finally the business changed hands or closed down, and brought to public notice a motley collection of etceteras which the hand of time had rendered obsolete.

Accounts were hand-written by steel-nib pen, for a typewritten bill would have seemed much too impersonal in this intimate set-up.

D. G. Roper

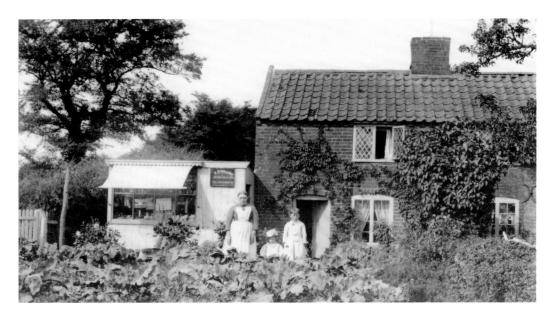

VILLAGE SHOP AT WALDRINGFIELD

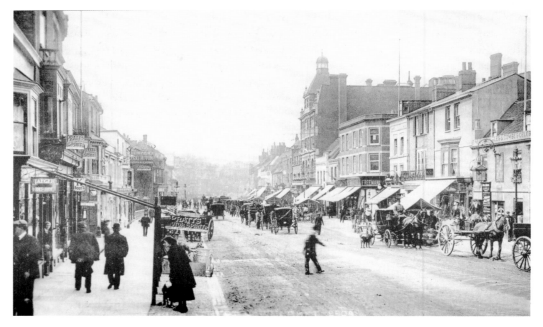

HIGH STREET, NEWMARKET

INTRODUCTION OF OLD AGE PENSION

Soham. To celebrate the inauguration of the Old Age Pension peals were rung at intervals throughout the day on the church bells. The ringers were entertained to dinner at the White Hart Hotel, the cost of which was defrayed to public subscription. . . .

Bury St Edmund . . . Although occasionally a demonstrative recipient was forthcoming, by far the greater number left the Post Office, after obtaining their old-age pensions, as if nothing exceptional had occurred. In the case of some persons who had clearly come down from a better worldly position, there was a disposition to keep the fact a secret that they had become recipients of old-age pensions. Nevertheless all seemed glad that better luck had dawned upon them with the New Year. . . Those putting in an appearance represented all stages in disposition and physical health. There were smiling faces, and features lined with care and sorrow; figures erect and firm, and bodies bent with the weight of care and toil. But all alike welcomed their pension, and received it with gratitude betrayed in their features if not expressed in words.

Cockfield. Twenty-four old people applied for their pensions at Cockfield Post Office on Friday. Cockfield is a large scattered parish, consequently some came a considerable distance. Some will have to walk six miles at least each week for their pensions. The majority of the pensioners are or have been agricultural labourers,

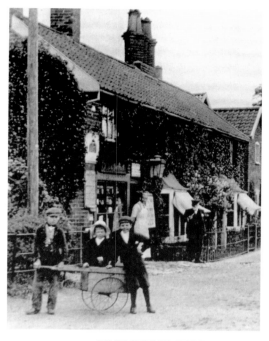

POST OFFICE, DENNINGTON

and the conversation between old friends who had not seen one another for years was quite interesting—their faces reflecting the hard rough life which had been their portion. Many had to put a cross, being unable to write their names. There are only three couples who are entitled to the pension. One old pensioner said he would be 76 in February, and he has had a rough experience, having had to earn his own living since he was twelve. He married when he was 23, and has brought up a family of ten, and can well remember the time when flour was 4s. a stone. He worked on the railway when the line was being made, for three years, but he is a thatcher.

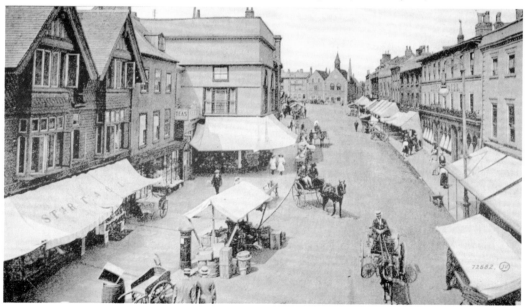

BUTTER MARKET, BURY ST EDMUNDS

Unfortunately some time ago he fell off a ladder and hurt his back, consequently he has been looking forward to the pension. His wife, who is also entitled to a pension, has been an invalid for 40 years.

Mildenhall. . . The act will relieve many old persons in the labouring class who have managed to struggle along without calling upon the parish for aid, and widows who have existed on precarious means, supplemented in a large number of cases by help from their children or other relatives. A typical case in the latter category is that of an old lady of 74, the widow of a farmer who died 23 year ago, leaving her in anything but affluent circumstances, which were much reduced by a lengthy illness. She has brought up a family of twelve, of whom nine are living, but nearly all have emigrated to foreign parts. Born in the parish of Mildenhall, she has lived in it all her life, and since her husband's death has just managed to make ends meet by taking lodgers, and monetary help from her children. Increasing age has reduced her ability to look after lodgers, so the pension comes at an opportune time for her. A sister, some years her senior, and likewise the widow of a local farmer, also comes in for a pension, which will be of great service during her declining years.

The Bury Free Press, *9 January 1909*

LAXFIELD SPARROW CLUB

The sparrow nuisance having become serious in the parish of Laxfield, at a recent meeting of the Parish Council—Mr T. H. Bryant presiding—it was decided to recommend the formation of a sparrow club. At a subsequent meeting it was resolved to form a sparrow club, and a voluntary rate of 1d per acre was agreed to. Mr G. Read promised to collect the rate voluntarily. Mr Henry Easey to recover and pay for sparrows and Mr T. H. Bryant to act as hon. secretary. In the first week nearly 1,000 sparrows were received.

Suffolk Chronicle and Mercury, *10 Feb. 1905*

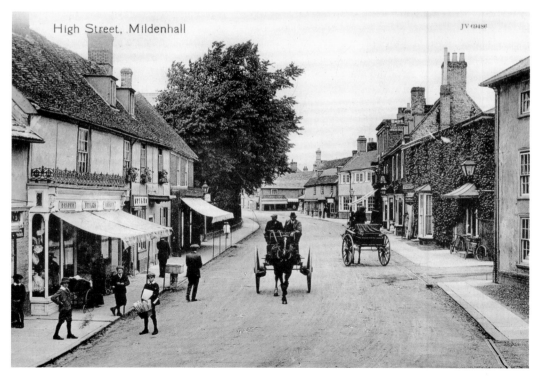

High Street, Mildenhall

HIGH STREET, MILDENHALL

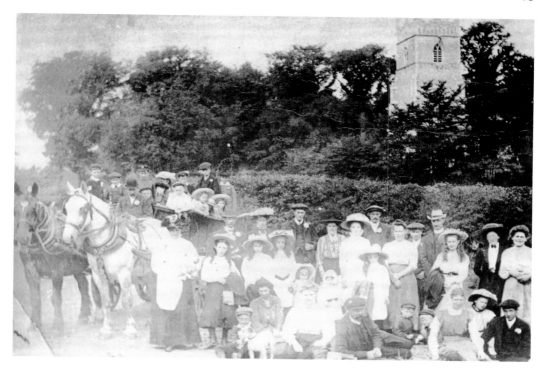

CHURCH OUTING, WALDRINGFIELD

GETTING MARRIED

In those days every young man and girl used to attend church or chapel and that was where they started looking for a sweetheart. That was generally how things began, on winter evenings, mostly, after the service. A shy young man would step up to two girls as they went home. He'd begin talking to one of them but he wouldn't have the courage to go right home with her the first time. But after about three Sundays he would become a little more sure of himself and the other girl would then leave the field to her friend. Thus things progressed a bit and the couple would be 'walking out'.

There was no fuss about engagements or engagement rings with the working people of those days but when the young man bought the wedding ring he generally bought what was called a 'keeper' with it and then he would start in earnest to save for a little home. No young man of that time thought of marrying a girl unless he had a home for her and had paid for it.

About two years after courting had started in earnest thoughts would turn to marriage. The girl would try to contribute things to the home. Her trousseau, which often consisted of half-a-dozen of everything, was often made of brown calico by the girl herself—and many a happy thought went into the work.

Then the great day arrived. The wedding party always walked to church. There would be about six of them. Behind the bride and her father walked the bridgegroom and a bridesmaid, then the best man and perhaps another bridesmaid or the girl's mother. Sometimes they would walk two miles like that. Of course, coming back, the bride and bridegroom would walk in front and people would call out 'good luck' to them as they passed.

The wedding celebrations started only after their friends had finished work for the day, as so many of them could not afford to have money deducted from their wages for lost time. The party was held at the bride's home and the guests took their presents with them. . . a set of jugs, some cups and saucers, a mirror, a saucepan.

Then they settled down to a good meal and the celebrations continued until about two o'clock in the morning. Then everyone went home for they had all (including the bridegroom) to be at work next day and in the summertime work started at six.

Emily E. Gray

THE FIRST PERFORMANCE OF *CHARLEY'S AUNT*

The lessee of the theatre is to be congratulated upon the brilliant success which attended the production on Monday week on the occasion of the Hunt Bespeak, of Brandon Thomas's new three-act play *Charley's Aunt*, which was played in a highly capable manner by Mr W. S. Penley, and a high-class London Company. In the previous theatrical season the Suffolk Hunt revived an old custom, formerly much in favour, of bespeaking a performance, and on Monday evening they again favoured the management, the result being a large and fashionable attendance, the performance being under the patronage of Mr J. M. King (Master of the Hunt) and Mr E. W. Greene (Master of the Staghounds). Mr King and several other members of the Hunt favoured the occasion with their presence. Of course the great attraction was the appearance in the title role of 'Charley's Aunt' of Mr W. S. Penley, whose part in *The Private Secretary* has now become historic, and in the role he assumes in the new play the histrionic power and capable acting of this clever comedian were such as to more than sustain the very high standard which Mr Penley has attained in past performances. *Charley's Aunt* is a smartly-written and delightful funny little production, which, while it bespeaks credit for the authorship, will not fail to command the support of that large section of the Art dramatic who delight in bona fide comedy as distinct from extravaganza, and with the services of a company so thoroughly capable as that which Mr Penley has succeeded in enlisting for the representation of the comedy, a very successful run may be predicted for the new play. Its effective presentation on Monday evening was not a little enhanced by the new and appropriate scenery of the several acts, the tasteful and effective appointments, and, by no means least, the charming and specially-designed costumes of the lady artistes. The piece is brim full of rollicking fun, which evolves from a series of embarrassing contretemps, most cleverly worked out by the playwright, and to which Mr Penley is the chief contributor in this ineffably droll impersonation of 'Charley's Aunt'. The other characters, though to a large extent subsidiary, give plenty of scope for effective acting, and it must be conceded the parts are most creditably taken by each and all of this talented Company without exception.

The Bury Post, *8 March 1892*

THEATRE ROYAL, BURY ST EDMUNDS

POOL'S PANORAMA OF MYRIORAMA

But perhaps the best entertainment of all (at the Public Hall, Ipswich) was 'Pool's Panorama'. It consisted of huge painted pictures which were operated by vertical rollers from the wings of the stage. A very important looking individual in evening rig-out would stand on the stage and give what was in effect a lecture. . . The lecturer would be describing some peaceful scene which the picture would show and then he would say at some previous time a battle had taken place there. Then would come the sensation 'By a wonderful scientific, dramatic and instantaneous effect', he would say, we would in a moment see the same scene while the battle raged,. The drums would roll and, sure enough, the peaceful scene would fade and the battle scene appear.

The effect was produced, of course, by changing the lighting from the front to the back of the picture, the back being painted with dark, brilliant colours while the front was very pale. This transformation always produced a gasp of astonishment from the audience.

L. J. Tibbenham

BURY ST EDMUNDS, CHRISTMAS, 1900

The change in the weather, which took place a few days before Christmas, with the advent of the new moon, did not hold out for the holiday season. On Saturday and Sunday the thermometer fell considerably and a sharp frost set in. Another change took place, and Christmas Day and Boxing Day were characterised by spring-like weather, but with a close, muggy atmosphere. Taking into consideration the fact that the war still holds out its course, with little promise of an abatement, and that thereby the homes of so many of our countrymen have been desolated by the loss of husbands and fathers, or the return home of invalided relatives, the season appears to have been as much enjoyed as any of its predecessors. The Postal Authorities were for days kept busily employed by the constant stream of folk sending missives to their friends, in the kindly Christmas greeting or the more substantial parcels. In fact, on Friday evening the Post Office was perfectly besieged, and the deliveries were somewhat delayed on Christmas Day by reason of the inrush of correspondence. The usual Christmas services took place at the various churches, and were well attended, and at our public institutions the lot of the inmates was considerably mitigated by the good fare provided.

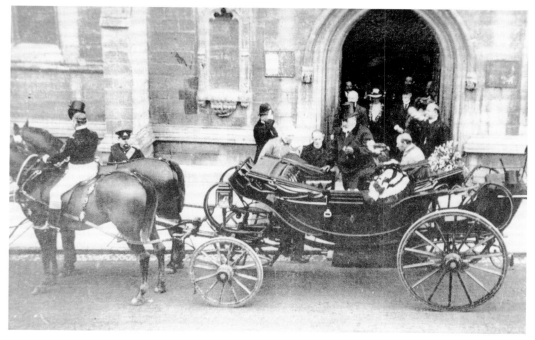

EDWARD VII AT BURY ST EDMUNDS

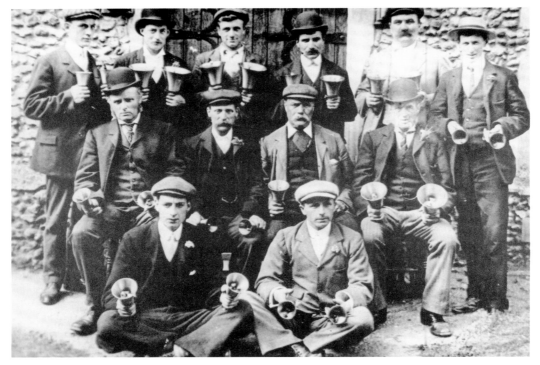

BELL RINGERS, BURY ST EDMUNDS

THE WORKHOUSE

The inmates of the Thingoe Union Workhouse were also well looked after on Christmas Day. The ordinary diet was varied by roast beef and plum pudding and vegetables, with beer for dinner, which was thoroughly enjoyed in the dining room of the institution, the walls of which were decorated with evergreens for the occasion by Porter Watkins, under the superintendence of Mr E. G. Roach, the Master, who, with the Matron (Mrs Roach), did all they could to make the time pass as enjoyably as possible during the festive season. Both the men and women's quarters were also decorated, and in one of the men's day rooms we noticed a number of suitable mottoes, admirably executed by one of the inmates, including, 'Old men's gratitude to the ratepayers', 'Compliments of the season', 'May the roast beef of Old England never want for an Irish potato', 'In remembrance of our loving Saviour', 'Health and happiness to our generous benefactors', &c. After dinner on Christmas Day, oranges, biscuits, tobacco, and snuff were distributed to the inmates, and buns were added to the ordinary diet for tea. Christmas letters were kindly sent for the inmates by Mrs Paine, and sweets by Mr Stockbridge. In the evening a miscellaneous entertainment was given by the nurses, under the superintendence and with the assistance of the Master and Matron, and it was quite evidence by the spontaneous expressions of the inmates on the following day that they thoroughly enjoyed themselves. The Chapel in connection with the House was also very neatly decorated, and at the service on Christmas Day the Revd J. Morgan (Chaplain to the Workhouse) preached an appropriate sermon, Mr Debenham presiding at the organ. On Boxing Day the inmates were allowed the privilege of leaving the House for the day in order to visit their friends.

Bury Free Press, *29 Dec. 1900*

SCHOOL AND FOOD

Arthur W. Welton (born 1884) also helped to teach his grandfather. He had gone to school at Blaxhall where he paid twopence a week, and a penny for the slate and a halfpenny for a pencil: 'When my mother had got the money we went, and when she hadn't we didn't go.' Later, when he was about fourteen, he moved to another Suffolk village a few miles away.

'I can't remember the time right well. I was living with my grandparents at Benhall. My grandfather was John Edwards, *Owd England*; my father, John Welton, married his daughter in 1855. She was called Hannah Edwards and was my mother. I reckon Owd England was born around about 1830. Anyhow he was getting very old when I knew him as a young lad but he thought he would like to write his name. He wanted to write his name. So I writ it down for him and he copied it; and after a bit he started to write so he could make out his own name. That was over seventy year ago. I remember him well. He was rather a big man. He couldn't get down to trim his feet. I used to cut his corns. Many a time I cut his corns

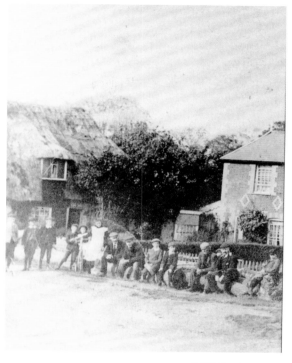

GRUNDISBURGH

and his toenails. Yes, and I learned him to write his own name; and he could read a little as well.'

As already suggested the living conditions of the school children varied from village to village. William Spalding, a stallion leader (born 1896), knew some of the worst:

'There were nine of us and we had a very hard time to get enough food to live. We had to work very hard after

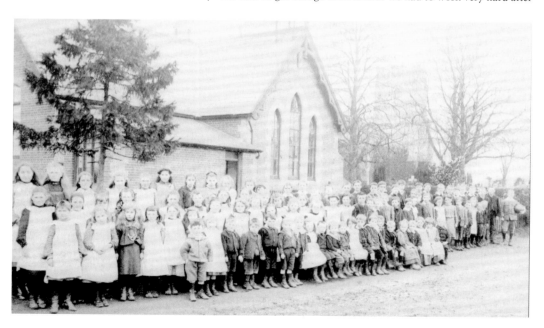

THORNDON

tea, after we come home from school, doing various jobs like carting wood and so on. I had no boots in them days. And I know what it was like to fling a crust of bread and dripp'n' away one day and go looking for it the next because I was so hungry. I was often hungry. And I used to pick the oats out of the bowl—what the horses had to eat from—plenty of times.'

At Helmingham during the lean times no children went as hungry as this. Mrs D. Manning (born 1900) recalls: 'During the worst part of the winter—that would be just before Christmas or just after—Lady Tollemache used to provide soup for the poorer families. We used to fetch the soup from the Hall when school finished. It was venison soup from the deer in the park. They used to kill so many deer a week

WALDRINGFIELD

and then boil up the venison in a big copper. *Buck-soup* we used to call it. The bigger boys and girls, if the mothers couldn't go, used to bring their cans to school and then they'd be let out at half-past eleven to go up to the Hall and fetch it—which they could do and leave it until they went home from school. And sometimes the lids came off the cans and two sticks went in to fish out a piece of meat before we reached home.'

An entry in the Helmingham school log book for December 1899 confirms that the family at the Hall gave a great deal of direct help to the village:

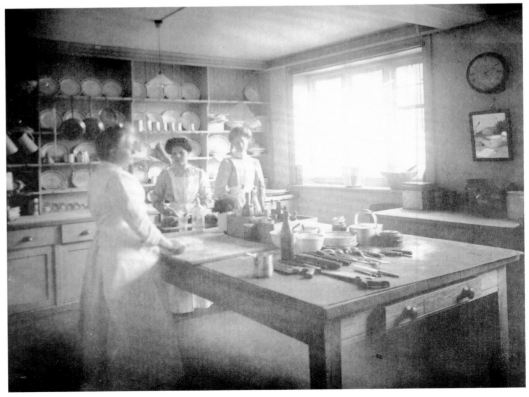

KITCHEN INTERIOR, THORPENESS

6½ stones of Beef and 508 lbs of plum pudding were given away at the School to the Cottage Tenants of the Estate. 75 lbs of plum pudding were also sent to the Allotment holders.

Charles S. Thompson said in this connection: 'The Dowager Lady Tollemache took great interest in the village clubs. These were started to encourage thrift, and they consisted of a coal club for both Helmingham and Framsden, and a clothing club for these two villages. There were a children's clothing club, a children's boot club and a coal club as well. The children had cards and I received their weekly contributions and entered them on the cards. The cards were totalled in October of each year and a bonus was added to each card by her Ladyship [3s to the clothing, 6d to the boot, 1s 6d to each coal club card]. Some of the boot and coal club cards were passed to local shops in Debenham and Coddenham. But—this is the interesting part—to save holders of clothing cards the fare to Ipswich, a "shop" was opened for the whole of one Saturday in the school and was stocked with two van loads of goods. The vans were drawn by horses and came out from Fish and Sons of Ipswich. Generally, four assistants from the shop were in charge. All clothing cards were redeemed during the day and the full account was returned to me and the cards. I know the firm's assistants enjoyed their day in the country—as well as the beer which was included in the load. The advent of the bicycle—and later the motor-bus—tempted people to visit the Ipswich shops themselves, so eventually our school "shop" was closed:

George Ewart Evans

A SUFFOLK FARM

In 1909 I became friendly with the son of an old established farming family which, in those days, farmed several hundred acres on the Norfolk/Suffolk border.

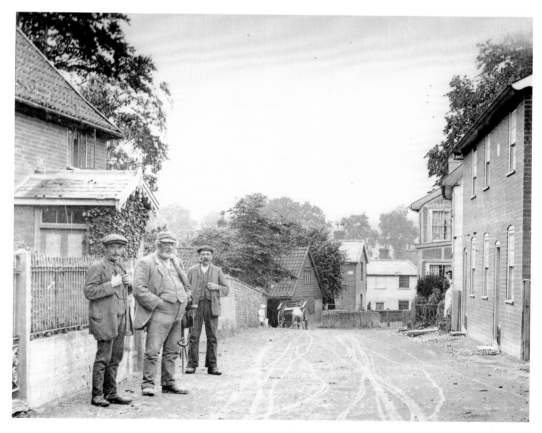

CODDENHAM

It is interesting to recall how very nearly self-supporting they were in the old days. I can still remember the enormous meals with almost all the food home produced. Sunday evenings were the highlight of the week. It was then, and I believe still is, the custom of farming families to visit each other frequently; and what better time than in the early evening of a summer Sunday. Visitors would arrive in their smart traps and buggies, with their high stepping cobs; the ladies' dresses beautifully in the fashion of the day.

In a very short time a dozen or more vistors would be gathered in the drawing room, the men discussing the latest prices and what the chances were of a good haysel, the ladies talking of the health of their children, progress at the local grammar school and what they were getting for their eggs, butter and poultry.

People were very musical in those days. Soon we would be listening to such lovely old melodies as Liebestraum, Melody in F, and Simple Aveu. Then the men would sing: My Ain Folk, An English Rose, Songs of Araby, Thora and many more. One old favourite was a certainty, and in which everyone joined—John Peel.

Farmers are of necessity early risers, so soon after nine o'clock the last visitor would have gone his way. Then would come supper—ham, salad, preserves, fruit and lots of cream, beer, cider or tea. And so to bed, each with his own little paraffin lamp for the bedside table.

E. G. Elam

THE NEW COLONY AT HOLLESLEY

At the last meeting of the London Central Unemployment Committee it was stated that an agreement had been drawn up for a three years' tenancy of the Hollesley Bay Estate at a peppercorn rent, with the option of the purchase of the 1,300 acres, buildings etc., at the end of the period, on satisfactory terms. Three hundred men will be working on the estate within the next three weeks, and will be engaged in making a road two miles long across the property to the landing-stage on the riverside, so as to facilitate the conveyance of produce to the river and thence to the London markets. The estate is to be regarded as the nursery for the emigration part of the Committee's work.

The Suffolk Chronicle, 10 February 1905

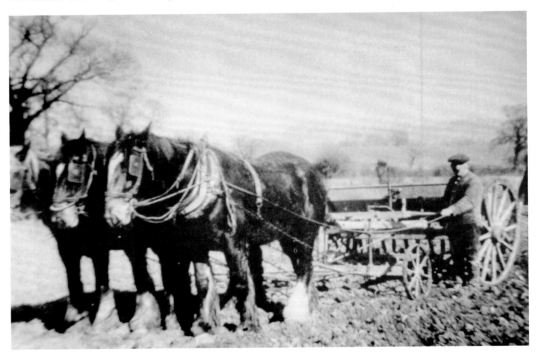

DRILLING CORN WITH A SMYTH DRILL

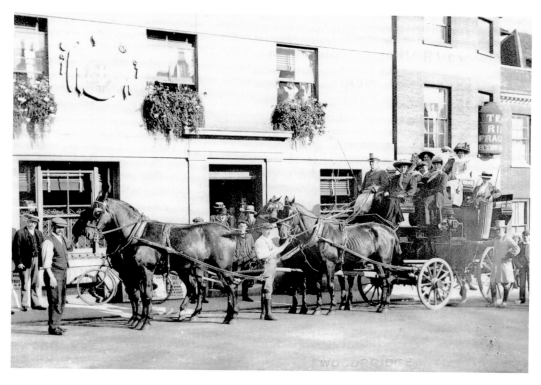

THE BULL INN, WOODBRIDGE

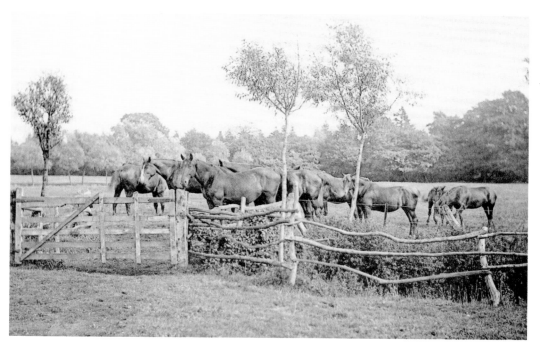

SUFFOLK HORSES AT HOLLESLEY

FOXHALL FARM

On one day of our stay with him Mr Pretyman took us to see some of his in-hand farms. The first of these that we visited was the Foxhall Farm, of which Mr Horace Dawson was bailiff: This is a holding of 1,250 acres of which 800 are arable, 400 heath, and fifty grass. Three hundred and fifty ewes were kept on it, of which the lambs were sold out in July at an average price of 31s. Here I came across another case of land that is poisonous to sheep.

The shepherd told me that on a certain young layer twenty-six lambs became paralysed and died owing to the presence of a plant that grew there, of which, however, I could not discover the name. These poisonous pieces of land were, he said, well known. On one side of the road it might be quite safe for sheep and on the other deadly. He told me also that folding sheep on a two-year layer there would give them red-worm in the lungs—'strongylus' I think it is called—the same disease which is so fatal in Lincolnshire. The capital employed in that farm was

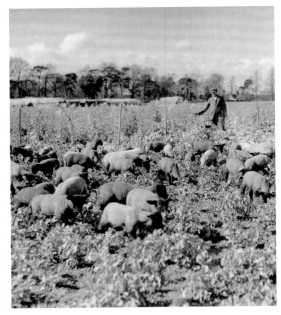

SUFFOLK SHEEP FOLDED ON ROOTS

£6 an acre. The system practised on this land, which was tilled with a double-furrow plough drawn by three horses, was: layers with manure; oats; kail or root crop without manure; and barley. Both Mr Pretyman and Mr Dawson told me they considered kail about the best crop that it would grow, and that which we saw there was particularly good. The sheep, I was informed, did exceedingly well upon it.

Here we saw the great Heath which runs from Ipswich to the Deben, a length of seven miles, and is from one to three miles broad. Also there were extensive young plantations, then in their third year, of larch, Scotch fir,

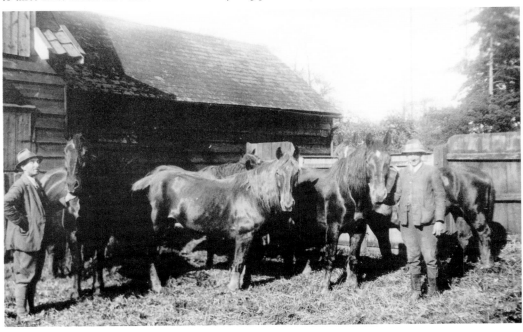

SUFFOLK HORSES IN STOCKYARD

spruce, chestnut, and a few oaks. After the land has been double ploughed these trees are planted in it four feet apart, and carefully fenced to keep out stock and game. On the whole they were doing well, although on some scaldy soil the drought had checked them. No wheat was grown on this farm. At Foxhall, where we saw old coprolite pits, the fabric of a deserted church has been made use of as farm buildings, and I was told that when sinking posts for the cow-yard the labourers had come across skeletons of the dead who lie buried there.

In this district the Crag, a shelly deposit of gravel and sand, generally overlying London clay, is very common. This Crag is a natural sponge, and by bleeding it pure water is obtained that never varies in quality or quantity. Below the Crag slope lies the valley of the Brightwell stream, which used to be an impassable bog of black peat on London clay, but now has been drained and is the grazing ground of young stock, Red Polls, Shorthorns, and blue-roan Angus. The Red Polls that I saw here I thought of a very good quality, and the horses were of the old Suffolk breed, which Arthur Young admired so much long ago, rather small in size, but docile, well-shaped animals, chestnut in colour, with their eyes set very wide apart.

H. Rider Haggard

NEW STYLE OF FARMING

Within two miles of Lavenham the country was bleak, lonesome, and undulating. Here we saw some empty cottages, also winter barley, which is grown to a certain extent in this district. In parts of Cockfield the cottages were very bad and had leaky roofs. My companion informed me that, taking the average of these parishes, they were badly farmed and full of misery. In fact they all declared that 'the industry is in a parlous state—on the verge of ruin, in fact'.

Here I came across a new style of farming practised by Mr Dyer, who held seventy acres in the parish. He kept thousands of turkeys, geese, ducks and fowls, some of which I saw being driven along in great droves, the geese and the ducks mixed together. These geese were bought at about 4s. and the turkeys at about 6s. a head in Ireland, delivered, but the ducks and fowls came from Norfolk. Mr Dyer's practice, I was told, was to hire stubbles from the neighbouring farmers at 6d. the acre, on which his stock ran. Also he bought cows and fed meal and milk to the turkeys, and dry meal, mixed I think, with pulped mangold to the other fowls. It was reckoned that the geese ought to double their incoming price before they were sold, while the turkeys all went out before Christmas.

H. Rider Haggard

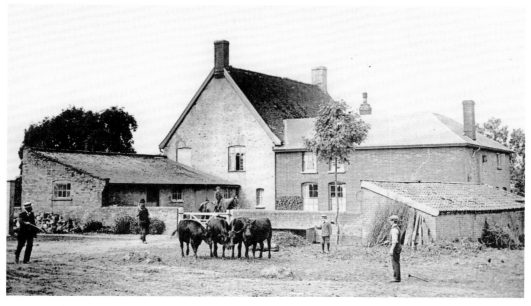

RED POLLS IN FARMYARD

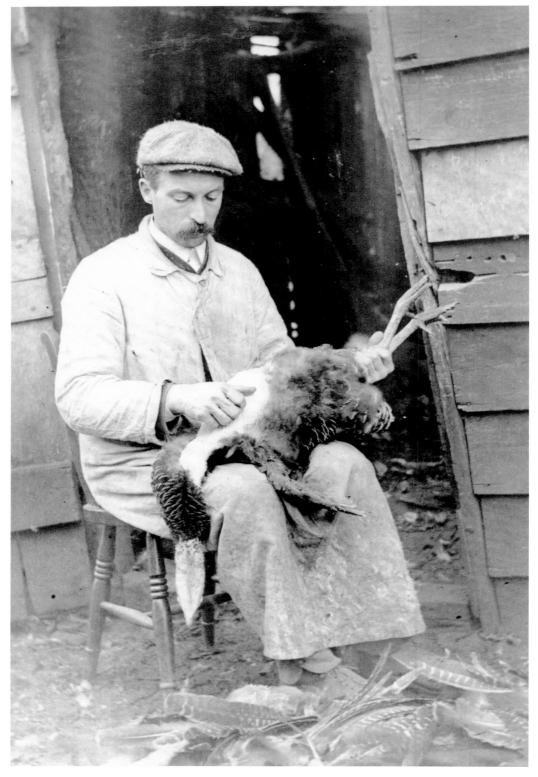

PLUCKING A TURKEY AT PLAYFORD

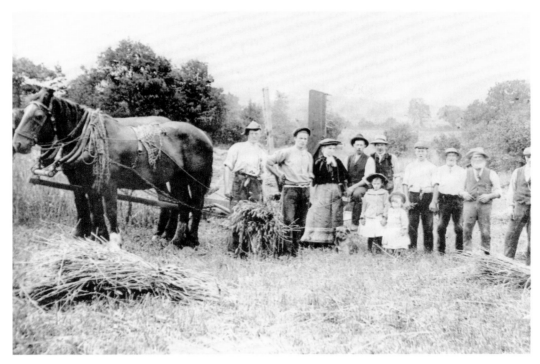

HARVESTING WITH HORSES AND SAIL REAPER

BUYING A REAPER

We are considering the advisability of buying a reaper—an expense that seems to be justified by our corn area. I have been to Bungay this afternoon to look at a specimen which is highly recommended, a very light but strong and serviceable machine of American make. It is curious, by the way, that the Americans should have won such a hold of the market in agricultural machinery. I suppose that there are English-made reapers, and as, on the Christian principle of turning the other cheek to the smiter, I prefer giving my support, insignificant as it may be, to home industries, I should have been glad to buy one, but there do not seem to be any on show at Bungay. If manufacturers wish to sell their articles they must have local agents to push them. Farmers, very naturally, have a great dislike to buying things through advertisements only, or that are sent by some distant firm. If they buy at home, not only do they give their custom among their own people, but also the local merchant who sells to them is more or less responsible for the article sold, and will generally undertake its repair. The advantage of this can scarcely be over-estimated, especially in the case of any sudden breakage while the machine is in active use.

The price of this machine—that is a reaper only, not a binder—is 26/., which seems a good deal of money for a farmer in these times to expend on one article. In certain seasons, however, it is quite possible that it would pay its cost twice over, for when the spell of fine weather is short, the rapid work of a machine has an enormous advantage over the slow toil of the labourer, even if the labourer can be found, which nowadays is not always the case. It is, however, a mistake to suppose that a reaper will cut corn in every case and every season. So long as the straw stands up quite straight it will deal with it admirably, but if it is badly laid and twisted about, the machine often does more harm than good. Nor is it safe to use it among very tall and thick beans if they are in the least beaten down. Here also we do not put a reaper into barley, as the treading of the horses is too destructive to that delicate grain; moreover, the machine throws off the corn in sheaves or bundles, which is not good for barley, that should be spread out thin to dry as it leaves the scythe.

H. Rider Haggard

THE HAY TRADE

'When he—Father—made up the trusses of hay for Newmarket and London he used a machine. Three men worked it. There was the foreman who did the cutting; the others made the *binds* and so on. The art was in cutting the truss out of the stack, and to know the way. You see, it might be a heavy stack, of heavy hay; and you wouldn't want so much in size because it would have weight. But if it was light—which was never so good—it had to be a rather bulky truss. I believe they weighed about four stone and a half. And I think they always allowed a pound or two for a certain amount of wastage. Well, then of course, my father used to send a press and three men to Havergate Island near Orford. It was a difficult job to get it across the river there on a flat-bottomed ferry affair. Well, on one occasion they had it in the water! and they had a terrible job getting it out. Then, of course, these men had to have lodgings, if they were going down to Havergate Island or to Beccles. They'd got to be found lodgings. And that wasn't always easy.

'The press was drawn by a horse, a cart-horse; and generally it was the farmer's duty—if you were cutting for one farmer near Wickham Market, say, and you'd got to move the press to Orford, well, the farmer who'd had it last would put his horse in and take it half-way; and those who'd want it at Orford would meet him with a horse and take it. It was a slow business. But it was fascinating, you know, not such a mighty rush. The pace was different. I don't say that they were the *good old days*, because they weren't. Oh! No! No! But we were all happy together, if you know what I mean. You take farming: the men *and* their wives, mind you, we were their interest and they were ours. It was our duty: of course, they were poor in those days. And the same in a country parish: people like us (we weren't wealthy, mind you, but we had a certain amount) it was our duty to see that the poor people of the parish were looked after. And if there was anybody ill, you got to go and see what was the matter with them, and see the doctor, and what they could have. And if they could have chicken-soup or hen-soup, you got to come home and kill it and make it. Because there was no health-service or anything like that. So these people—that is, most of the hay-cutters—came from nearby. But it was quite a lot, you know, quite a lot.'

George Ewart Evans

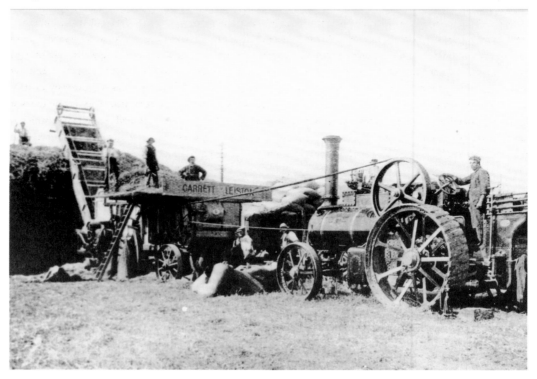

THRESHING WITH GARRETT TACKLE

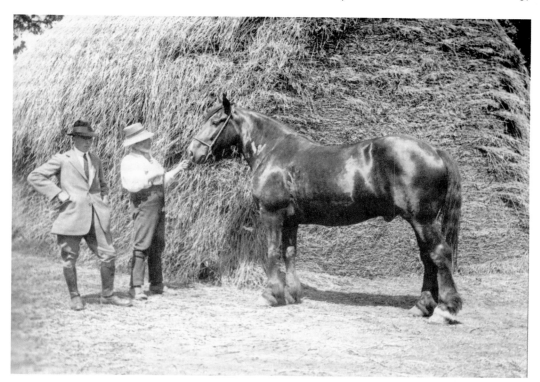

A SUFFOLK HORSE

A MODEL FARM

We walked over some of the Culford home farm of 1,000 acres, where the splendid model buildings and premises were fitted with water power and every other convenience. In the cowhouse, for instance, water was laid on to the troughs, and the food was carried on tramways. Also there were sliding doors, tile-lined walls, iron fittings, ample space, and perfect ventilation. In the same way the great covered yards had concreted paths, tramways and every other improvement that can tend to the well-being of cattle. The Jersey cows were worthy of their habitation, as was shown by the winning cards with which the wall plates were decorated. They lay on the best barley straw and were fed with bran, oats, chaff, linseed cake, and a superior meal made from maize, which is called Germ meal, all their food being cooked in a steaming-pan in cold weather. The pigs were Berkshires, but the bailiff Mr Turner, told me that these prize creatures were rather slow breeders. In the park we saw a beautiful flock of South Downs, of which 300 ewes were kept here, or, in all 1,000 sheep.

H. Rider Haggard

COCKFIELD

(He said that) in this parish, out of about 3,700 acres, 1,700 acres were in the hands of smallholders. These men lived and paid their rent, chiefly by growing corn and working from five in the morning till eight at night, but they had no money to buy stock and their land was full of twitch. The average rent of the heavy land in the neighbourhood was about 10s. the acre; but farms were pointed out to me which used to let from 42s. to 45s. the acre, and now brought in only 5s. 6d. the acre, out of which, of course, the landlord must keep up the buildings and pay the tithe. The wages were 16s. a week, including piece-work etc.

H. Rider Haggard

SIZE OF FARMS

The farms in our part of Suffolk were generally of moderate size. Three hundred acres might be put at about the maximum, while many were less than one hundred acres. The result was that the prosperity of the country was more evenly diffused than in the Chalk Hill districts of England, where the farms were far larger and successful men amassed great wealth. Our farmhouses lay close together, the majority of them picturesque white houses with high-pitched gable ends, and near them often stood old pollard elm trees, almost the only big trees on the farm. These were the nesting places of the white owls, the best of guardians against the swarms of mice which raided the corn ricks, and the farmers were wise enough to leave them in peace.

James Cornish

THE TENANT SHALL AGREE . . .

To cultivate the land according to the Four Course shift of Suffolk husbandry with liberty for the incoming tenant to come upon the said lands in the spring time and sow clover or other artificial grass seeds with the summerland crops of the last year, the sowing of which due notice shall be given to him.

To harrow in such grass seeds without any allowance.

Not to permit cattle to be turned on the lands sown with grass seeds (except hogs well ringed).

Not to take from off the same lands two white strawed crops in succession without the intervention of a green or pulse crop (except with written permission). Beans and peas to be twice clean hoed or a clean summertilth.

To spread on the lands and premises all the hay, stover, straw, turnips and other roots produced thereon . . .

To stack and inbarn on the premises all the corn, grain and pulses produced thereon.

In the last year to leave all the straw, chaff and colder of that year's crop well preserved for the Incoming tenant. . .

To spread on the land all the muck, manure, and compost, produced on the premises.

To yield up possession on the determination of the tenancy.

To sweep the chimneys of the farmhouse twice every year.

Not to assign or underlet the said farm lands and premises or any part thereof.

Not to top any pollard trees nor cut alders of younger growth than eight years nor of older growth than twelve years . . .

Extract from a Farm Tenancy Agreement, 1903

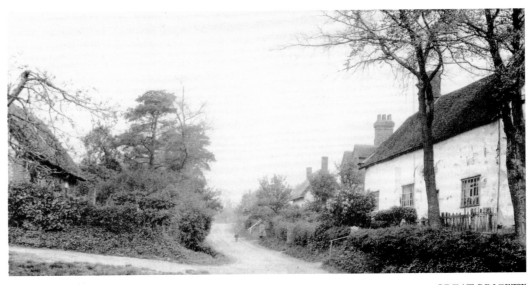

GREAT BRICETT

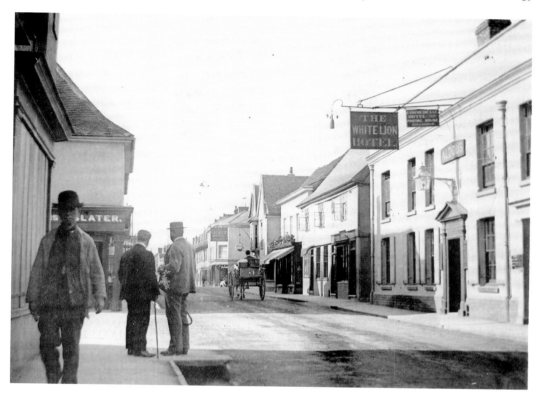

HADLEIGH

A ROWDY MEETING AT HADLEIGH

A meeting, under the auspices of the Central Association for stopping the sale of intoxicating liquors on Sunday, was held in the Town Hall on Monday evening. The chair was taken by the Revd J. F. Lepine, Congregational Minister, and when the hour appointed for the proceedings to commence arrived the hall was completely filled.

The Town Crier had been employed to call upon working men to assemble in force to uphold their rights and not allow public houses to be closed on Sunday. The Chairman having briefly opened the proceedings, Mr E. Whitwell, of Kendall, the hon. secretary of the association, proceeded to address the meeting, and had spoken but a very short time before interruption began from a number of young men and lads who had taken possession of the forms at the back of the room. The Chairman twice intervened, asking for a hearing from the speaker, and his appeal was for a short time complied with, but the disturbance was renewed. . . The Chairman again interposed, and a man named Deeks sitting on one of the front seats rose and asked the audience to be quiet. He was replied to by a shout of 'Shut up, Tinker', and the disturbers started 'We won't go home till morning.' Mr Whitwell endeavoured, among a great uproar, to continue. . . and asked for a show of hands on a resolution in favour of closing public houses for the whole of Sunday. This was, among a great deal of noise and confusion, said to be carried. . .

. . . Mr O. Blinkhorn, travelling secretary of the association, next essayed to speak, but the meeting would not listen to him, and this so raised his ire that he completely forgot what was due to the Chairman, the meeting and himself, and what is vulgarly called 'took a sight' at the audience. . . Mr Blinkhorn then apologised for his folly and ill breeding, but the audience were not satisfied, and, waiting till he came out, bustled and bonnetted him, and he was rather glad to get safely into the White Lion Hotel. . . It is fortunate that so popular a gentleman as Mr Lepine was in the chair, or it is not improbable that the crowd at the meeting would have forced their way onto the platform, and perhaps some serious damage to property or person might have followed.

Suffolk Chronicle, 15 October 1881

EXCISEMAN

One of the most widely known and greatly respected men in the parish was Mr William Emerson, the exciseman. His 'round' was a very long one, fourteen parishes I believe, and his main work the assessing of the duty that must be paid on malt. Though the maltings were less numerous than they had been in former years, there were still a considerable number left round us, and we grew our barley, made our malt, brewed our beer; and drank it, too, in enormous quantities. So few people have seen the excisemen at work that I had better describe the process of estimating the amount of duty payable on the malt. The equipment of a malting was large and elaborate. There was first the kiln where the malted barley (swelled after wetting and with little sproutlets shooting from the grain) dried till each sprout was as little as spun-glass. Next were the two great drying floors where the soaked grain was spread to the depth of perhaps a foot. In the first the wetted grain put out its little shoots, in the second the sprouts were allowed to grow for a time. Then came the wet vat, and this was the central point for the maltster and the exciseman. It

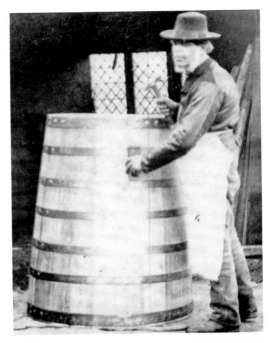

COOPER, PEASENHALL

was a carefully constructed tank about six feet long, four feet wide and four feet deep. In this the barley was placed. Then sufficient water was poured over it to reach the top of the grain and left to soak. When a maltster intended to wet his barley he was bound to give notice to the exciseman, and it was while the barley was in the vat that the exciseman measured the quantity and calculated the amount of duty that must be paid on it. It was very interesting to see Mr Emerson 'take his dip', as the phrase was. He levelled the surface of the wetted grain with great care and then measured the depth with his steelyard. He knew the length and breadth of the vat and then worked out a sum to get the cubic content of the barley. This he checked by a process which he called 'casting out the nines', a piece of arithmetic which I could not follow. From the vat he would go to the first drying floor and to the second drying floor and measure the malt there, though with less care, and take up a handful or two to see if it were all of the same quality and age. From his pocket he would produce a slide rule, adjust the piece of brass which lay in the ruler, and, again in a way which I could not follow, this used to tell him the cubic content of the malt on the floors.

James Cornish

CROWN BREWERY, LOWESTOFT

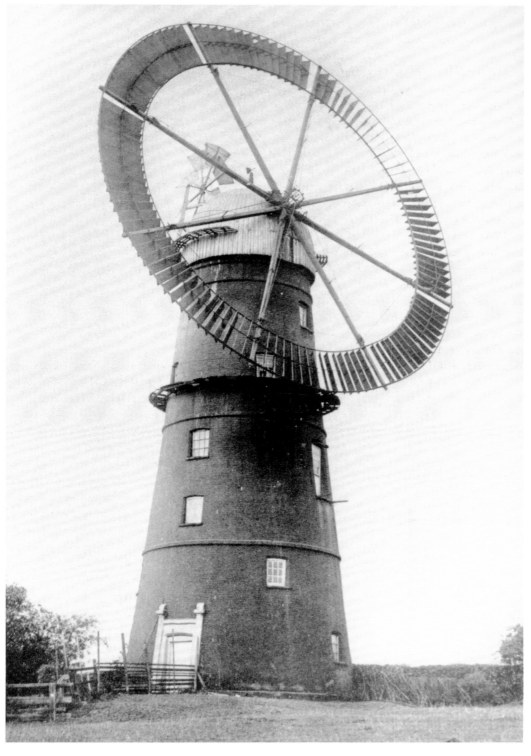

RUFFLES WINDMILL, HAVERHILL

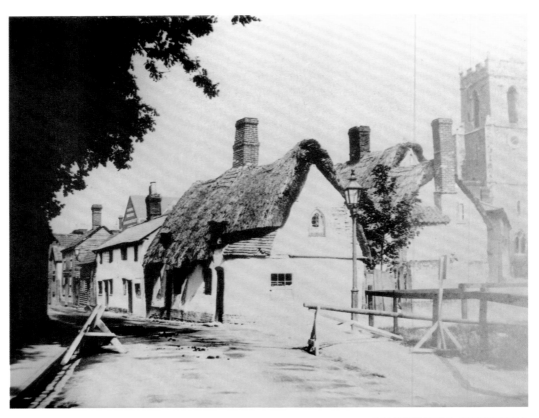

MARKET HILL, HAVERHILL

REMINISCENCES OF HAVERHILL

I went to the factory in Crown Passage (Gurteen's) and made shirts for 2/- a dozen. Our hours were from six in the morning (if we were not there by twenty past six we were locked out) until six at night. We went home to breakfast at quarter to nine and to dinner at one. The factory was not heated then and it was very cold in the winter. It was lit by gas. We had to work hard to earn from 10/- to 12/- a week. Rent was about 2/6 per week. We used to have bread and butter or jam or cheese for breakfast and for dinner suet pudding and potatoes and pork. We have very little beef.

The town was very different then. The paths were cobbled and the street in winter was very dirty and muddy. . . Halls had a brickyard and a good many men worked there. . . There were at least four blacksmiths. . . I remember all three mills with their sails turning—one boy swung on the sail of Castle Mill and was carried round. . .

Emily Elizabeth Webb

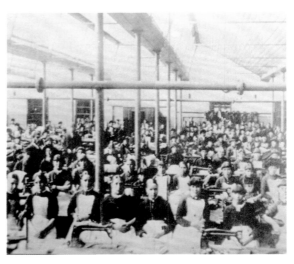

SEWING ROOM, GURTEEN FACTORY, HAVERHILL

HAVERHILL STREETS

Sir,

We are on the eve of a possible contest for seats on the Urban District Council and one may reasonably enquire whose duty it is to control the traffic of our streets and what are the relations subsisting between the Council and the police, for the danger of our roads and pathways at this season are greater than usual and nothing is done by either body for the safety of weary pilgrims and sojourners.

Nursemaids and perambulators we have always had with us and on market days three abreast, where the pavement is wide enough, but I am referring just especially to the numerous children, who with hoops, skipping ropes and whip tops, threaten injury to our poor feet and legs and with whip lashes endanger our blessed eyesight. Walking in High Street is bad enough, but it requires a large amount of courage to venture along Queens Street. Whilst children are leaving school woe betide the traveller who is hurrying to catch a train. . .

Surely the principal thoroughfares are not the place where two children should hold either end of a rope for a third to jump over as they walk home from school, but I meet several such trice daily—to say nothing of the top spinners all round. I tremble in my shoes but not in fear of the police or even of the Council.

Yours distractedly,

A perplexed pedestrian

Letter to South West Suffolk Echo, *17 March 1900*

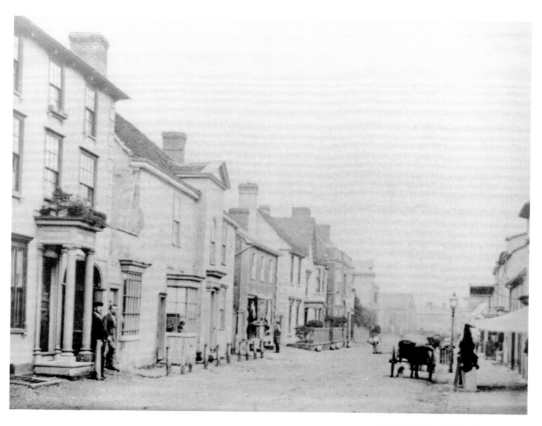

HIGH STREET, HAVERHILL

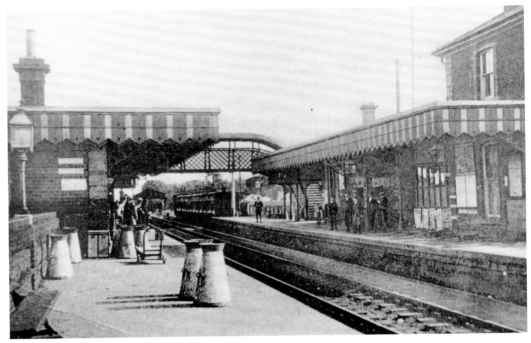

HAVERHILL RAILWAY STATION

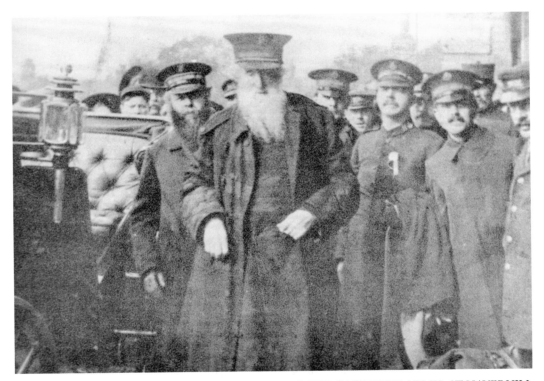

GENERAL BOOTH (SALVATION ARMY) AT HAVERHILL

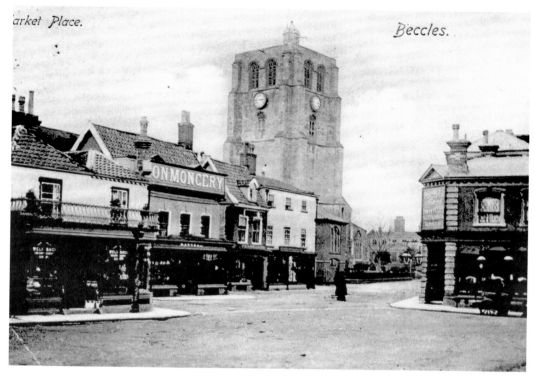

MARKET PLACE, BECCLES

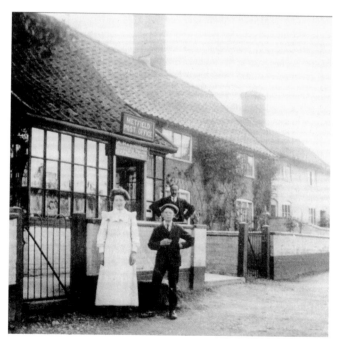

POST OFFICE, METFIELD

BECCLES POSTAL SERVICE

Three deliveries of letters and parcels were made daily, the last starting at 7.00 p.m. except on Sundays when there was only one delivery of letters. The parcel post had started in 1883, five dispatches were made every weekday. It was possible to post letters up to 11.50 a.m. for delivery that day in Ipswich, Norwich, Cambridge, chief towns in Essex and Suffolk and many towns within a fifty miles radius of London. Letters posted by 6.05 p.m. were delivered that day in Great Yarmouth, Lowestoft, Bungay and Harleston. The Post Office was open from 7.00 a.m. to 8.00 p.m.

Kelly's Directory, 1883

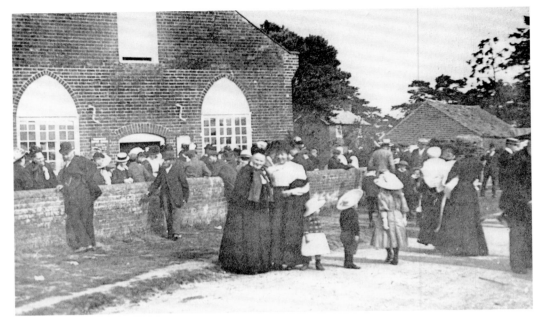

WALDRINGFIELD CHAPEL

A WALDRINGFIELD MEMORANDA CONCERNING SERVICES OF THE CHURCH

. . . a man may pursue his worldly work at one hour and be upon his knees in God's House at another the same day . . .

Again there is no inconsistency or impropriety in coming to Church in a *working dress*. Let a man if the occasion require it go straight from the plough and say his prayers in the congregation, and the soil upon his clothes will not hinder the blessing of God following.

Far more pleasing to God . . . than young men and maidens whose only object at a Sunday service seems to be to lounge or sleep or laugh or display a gay dress . . .

Revd T. H. Waller

REVD T. H. WALLER

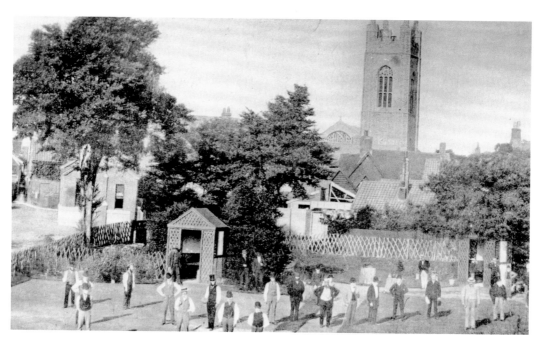

BANK HOLIDAY, BUNGAY, 1878

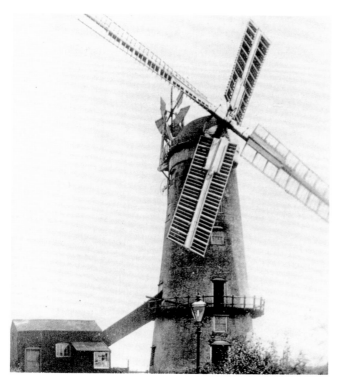

WINDMILL, BUNGAY

MARKET

Today is Bungay market, and Hood sold about fifty-six comb of wheat grown on the All Hallows land at 18s. 3d. the comb of 18 stone, or 36s. 6d. the quarter. This is sixpence less than he was offered last week; but the markets for corn are so dreadfully uncertain, and so much at the mercy of American 'comers' and speculators in 'futures', that it seems best to take it, as, for aught we know, by next sale day wheat may be down two or three shillings a quarter. Of course, on the other hand, it may be up, especially as it is said that there is really a shortage in the world's supply. But this it is not safe to count on.

H. Rider Haggard

ALDEBURGH LIFEBOAT DISASTER 1899

At Aldeburgh in the year 1899 there occurred what I believe to be the grimmest and most macabre life-boat disaster ever known in the history of the Life Boat Service, or, to be more correct, the Royal National Life Boat Institution.

A new lifeboat of the self-righting type, had been presented to, and named after, the town. The seventh of December that year was a day of violent winds and high seas. When the life-gun summoned the crew to the lifeboat-shed, the children of the crew had to be tied to the railings on the sea front, to prevent them being blown off their feet by the gale. After several desperate attempts to launch the boat thro' the hell of breakers and surfs alongshore, they eventually got her afloat. As the boat was of the new type the crew had been instructed to sit tight and hang on if she capsized, for she would right herself. She broached-to broadside-on to a huge comber, which broke aboard her, rolling her completely over. Slowly she righted, only to be rolled over again by a breaker which broke into her lugsail, this time nearer the shore. Two men ran out along the mast to be plucked from the sea by a human chain. A third time the gallant ship was rolled on her beam ends, most of the crew still clinging to her grimly, as instructed. But with the fourth breaker the Grim Reaper played the most horrible trick. The heavy lifeboat was hurled upside down on to the beach, crushing the life out of the unfortunate men who still clung to the boat.

In an instant the frantic onlookers, among whom were the wives of the trapped men, were waist deep in the water desperately trying to prize up the vessel from the shingle, in a vain effort to release the men. A gang of road menders at last managed to break through the boat's bottom, but it was too late. A scene of indescribable horror was revealed to the bystanders. The men were not drowned. They had been suffocated and crushed to death.

My grandmother had to compose the limbs of the victims of the pitiful accident. She told me that, before they could be properly laid to rest in their coffins, many had to have their arms and legs broken, so contorted were their poor bodies. She added that their mouths, eyes, ears and nostrils were choked with sand and small shingle.

In the churchyard of Aldeburgh there is to this day a splendid memorial to these men who gave their lives in the service of others.

George C. Carter

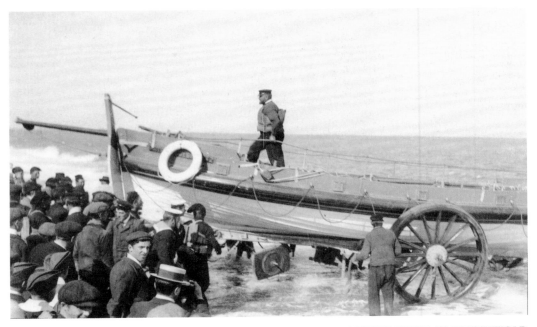

LIFEBOAT DEMONSTRATION AT SOUTHWOLD

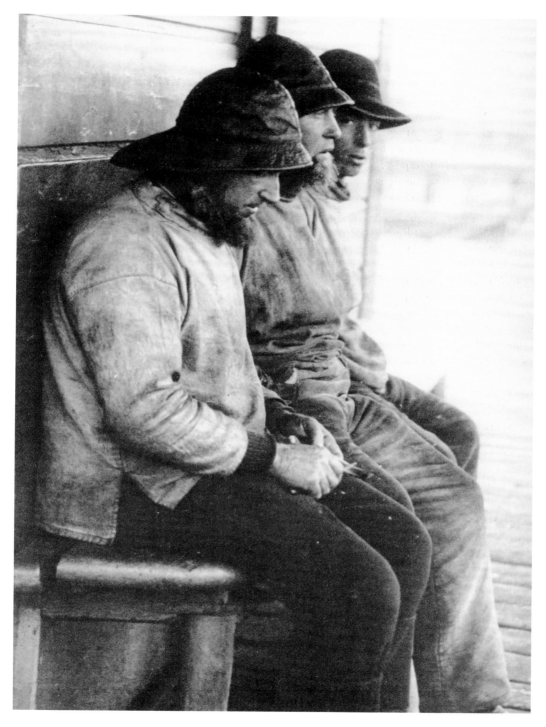

LOWESTOFT FISHERMEN

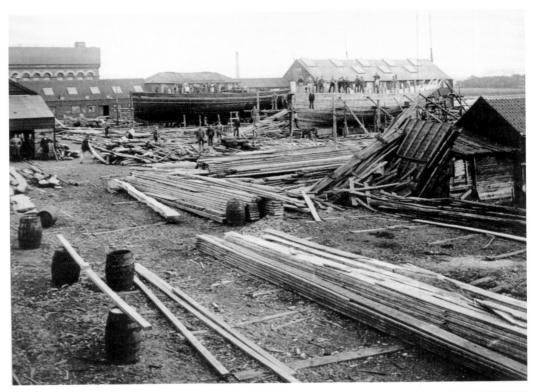

SHIPBUILDING YARD AT LOWESTOFT

ROYAL NATIONAL MISSION TO DEEP SEA FISHERMEN

A war was fought in the hostile waters of the North Sea during the 1880s. On one side were the vessels of the recently-formed Royal National Mission to Deep Sea Fishermen, dedicated to the cause of temperance and bringing spiritual and material comfort to the men of the fishing fleets.

Ranged against them were the notorious 'Copers'—vessels from the Continent which made a rich living selling grog and tobacco.

The Mission cause captured the imagination of many well-wishers in late Victorian England, and the simple expedient of undercutting the tobacco prices charged by the 'copers' and the provision of basic medical aid soon saw the tide running strongly in favour of the Mission.

In 1886 the Duchess of Grafton presented the sailing smack Euston for work on behalf of the Mission. The handing over ceremony took place at Yarmouth at the end of May.

And the occasion caused the *Lowestoft Journal* to reflect of the RNMDSF:

Among the elevating agencies in operation for the mental, moral and religious benefit of our deep sea fishermen, we know of none superior, even if they be comparable to the Mission, which, though only in its virtual infancy, has already effected a vast amount of good in the special department it seeks to cover, and to such places as Yarmouth, Lowestoft, Grimsby and other ports, which furnish such large numbers of vessels for the deep sea enterprise, the Mission is likely to prove of incalculable service and value.

The paper added:

It would seem that the Mission was established exactly at the right time. As the men manning the trawlers and fishing boats generally have long had a desire to be rid of the pestiferous influences of the Dutch 'copers', with whom for so many years they have been more or less compelled to do business, they are now, or at any events the greater part of them, quite ready to avail themselves of the agency thus providentially raised up for their welfare. . .

Due tribute was paid to the work of the founder of the Mission, E. J. Mather, and the *Journal* added:

There is one feature about the enterprise which strikes us as an exceedingly useful one—that is, the provision for surgical and medical aid. It was a capital idea to have the skippers of the Mission ships obtain a few rudimentary lessons in the healing art, and many a poor fellow overtaken by accident or sudden disease will have the advantage of being at once treated, to a certain extent at least, for their ailments, and thus frequently prevent much loss of time, and possibly life itself, by taking the cases in their initial condition.

Perhaps, however, the greatest advantage to the men, from a business point of view, will be the removal of that grand source of temptation from them, 'the copers', which, as most of our readers are aware, have been a prolific source of demoralisation to them.

By making the business of these gentry unprofitable, it is hoped that this will do more to drive them off the high seas than to restrain their dealings by legislative enactment.

This, we suppose, will be first tried, but if ineffectual recourse can then be had to the arm of the law, but which it is expected will not be required.

Nor, indeed, was it required. The Mission policy was quickly proved effective, and many a fishing vessel came to fly with pride the masthead pennant which indicated that no drink was taken on board.

Trevor Westgate

HUMOUR

Among the other Guildhall people were old Mrs 'Ratty' Kemp, widow of the Rat-catcher; old one-eyed Mrs Bond, and her deaf son John; old Mrs Wright, a great smoker; and Mrs Burrows, a soldier's widow, our only Irishwoman, from whom Monk Soham conceived no favourable opinion of the Sister Isle. Of people outside

RAMSHOLT DOCK

the Guildhall I will mention but one, James Wilding, a splendid type of the Suffolk labourer. He was a big strong man, whose strength served him one very ill turn. He was out one day after a hare, and a farm-bailiff, meeting him, tried to take his gun; James resisted, and snapped the man's arm. For this he got a year in Ipswich jail, where, however, he learnt to read, and formed a strong attachment for the chaplain, Mr Daniel. Afterwards, whenever any of us were driving over to Ipswich, and James met us, he would always say, 'If yeou see Mr Daniel, dew yeou give him my love.' Finally, an emigration agent got hold of James, and induced him to emigrate, with his wife, his large family, and his old one-legged mother, to somewhere near New Orleans. 'How are you going, Wilding?' asked my father a few days before they started. 'I don't fare to know rightly,' was the answer; 'but we're goin' to sleep the fust night at Debenham' (a village four miles off}, 'and that'll kinder break the jarney.'

So James Wilding is gone, and the others are all of them dead; but some stories still remain to be cleared off. There was the old farmer at the tithe dinner, who, on having some bread-sauce handed to him, extracted a great 'dollop' on the top of his knife, tasted it, and said, 'Don't chüse none.' There was the other who remarked of a particular pudding, that he 'could rise in the night-time and eat it'; and there was the third, who, supposing he should get but one plate, shovelled his fish-bones under the table. There was the boy in Monk Soham school

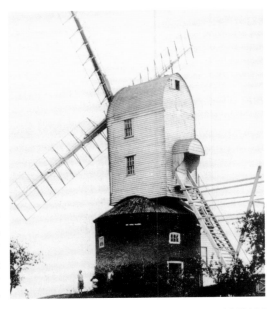

WINDMILL AT EARL SOHAM

who, asked to define an earthquake, said, 'It is when the 'arth shug itself, and swallow up the 'arth'; and there was his schoolmate, who said that 'America was discovered by British Columbia'. There was old Mullinger of Earl Soham, who thought it 'wrong of fooks to go up in a ballune, as that fare so bumptious to the Amighty'. There was the actual balloon, which had gone up somewhere in the West of England, and which came down in (I think) the neighbouring parish of Bedfield. As it floated over Monk Soham, the aeronaut shouted, 'Where am I?' to some harvesters, who, standing in a row, their forefingers pointed at him, shouted back, 'Yeou're in a ballune, bor.' There was old X, who, whenever my father visited him, would grumble, talk scandal, and abuse all his neighbours, always, however, winding up piously with 'But 'tis well.' There was the boy whom my father put in the stocks, but who escaped by unlacing his 'high-lows', and so withdrawing his feet. There was the clergyman, preaching in a strange church, who asked to have a glass of water in the pulpit, and who, after the sermon, remarked to the clerk in the vestry, 'That might have been gin-and-water, John, for all the people could tell.' And, taking the duty again there next Sunday, he found to his horror it *was* gin-and-water: 'I took the hint, sir—I took the hint,' quoth John, from the clerk's desk below.

Francis Hindes Groome, 1895

QUAY INN, REYDON

FAMILY GROUP, WALDRINGFIELD

NAMES

This continuity of tradition manifests itself in various ways. It is apparent in the names of the farm animals. Certain names for horses are common all over both counties, and are to be found on almost every farm, while others betray local and personal influences. From an average of a considerable number of farms, I think it will be found that the most popular names are Beauty, Captain, Brag and Prince, while other traditional names are Gipsy, Billy, Darling, Dipper and Depper, Kitty, Tinker, Boxer, Briton, Daisy, Peggy, Proctor, Snip, Farmer, Punch, Diamond, Smart, Duke, Short, Flower, Bunny, Tom or Tommy, Blossom, Smiler, Nelson and Scot. Then there is the group of personal names—Dolly, Gilbert, Jack, Sammy, Judy, Fred, George, Fanny, and May; those which may be taken as complimentary to appearance or breeding, such as Bonnie, Spruce, Jolly, Spanker, Smiler, Jove, Sprite, Duchess and Damsel; and those with some ancient relation to the animal which it is difficult now to understand. This includes Toppler, Gyp, Tinker, Sharper, Snip, Trimmer and Traveller. With the ordinary farm horses the naming is usually

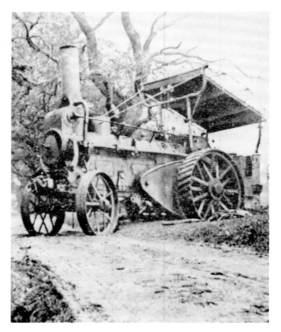

RANSOMES TRACTION ENGINE
IN A DITCH AT BEALINGS

left to the teammen, and this accounts for the persistence of certain traditional terms over a wide area. The cows on an average farm are named in somewhat similar fashion, but here the range is wider in one sense, and more limited in another, for feminine Christian names are usually applied, and Rose, Daisy, Polly, Molly, Jenny, with a few variations such as Blossom, Cherry and Brighteyes are those most generally in use.

Unchanging tradition is further evidenced by the words of direction to farm horses, and the various calls to stock. With the increasing employment of mechanical methods for agricultural operations, it is by no means improbable that the next generation of farm labourers will find no use for the conventional cries of command to plough-horses. In a sixteenth century song the waggoner is described as 'with nailed shooes and whipstaffe in his

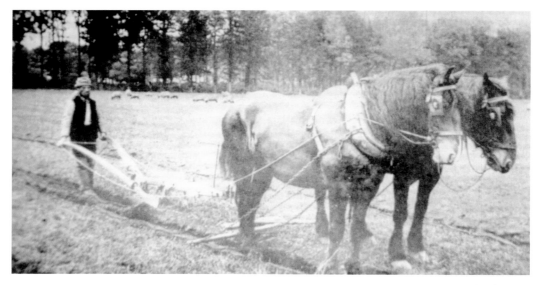

PLOUGHING

hand, who with a hey and a ree the beasts command'. 'Hey' corresponds with 'heit', and tells the horse to bear hither, or to the left. In East Anglia this command is either 'cup-hey', 'cub-baa', 'cub-bay', 'coopy-hay', 'cuppy-whoa', 'cuppy-whee', 'cuppy-hoult', or 'hait-wo' (French *hay ho*), and is applied to horses in a team. The 'ree' of the mediaeval waggoner meant right, as in 'riddle-me-ree'. To turn a horse to the right the forms are 'wooch', 'woosh', 'wish', and 'whoash', from the French gauche, yet used with the reverse meaning, as 'Wooch wo', go to the right. The ordinary calls 'Weh!' 'Woh!' for stopping the horse, and 'geeho', are traceable to Norman-French, and are known in France, while in Italy 'Gee-ho' is 'Gio'. Cowley, in his 'Guardian', has a line: 'Ere Phoebus cry Gee-hoe unto his team'. 'Gee-up' is the East Anglian form, and probably the child's 'Gee-gee' has a like origin. 'Coop, coop', or 'cup, cup', are the usual calls to horses in a pasture.

W. G. Clarke, 1921

SHEEP SHEARING

Today we have been baulk-splitting, cutting out thistles, and shearing the sheep. This latter is done by a gang of shearers, four in number, who travel with a pony and cart from farm to farm, clipping the sheep at a charge that averages about threepence a fleece. The operation is carried out thus: first the ewes—for of course the lambs are not clipped—are penned in one-half of the All Hallows barn, their offspring remaining outside, where they make a fearful din, auguring the very worst from this separation. A boy—the invariable boy who always appears upon these occasions—steals in delightedly to catch a ewe. As soon as they see him the whole flock rush about madly, as though they were executing a particularly confused set of kitchen lancers; but when once he has gripped one of them, after a few struggles she more or less resigns herself, and without any great resistance is half led, half dragged through the open hurdle to the malevolent looking person who, like one of the Roman Fates, is waiting for her with the shears. He seizes here, and with an adroit and practised movement causes her to sit upon her tail, in which position most ewes look extraordinarily foolish. Now she struggles no more, nor does she make any noise; indeed, in watching the operations this morning I was put very forcibly in mind of the prophetic verse in Isaiah: 'As a sheep before her shearers is dumb.'

The operator begins his task in the region of the belly, working gradually round towards the back until it is necessary to turn the animal on to her side, when he ties the fore and hind leg together with a thin cord. In the

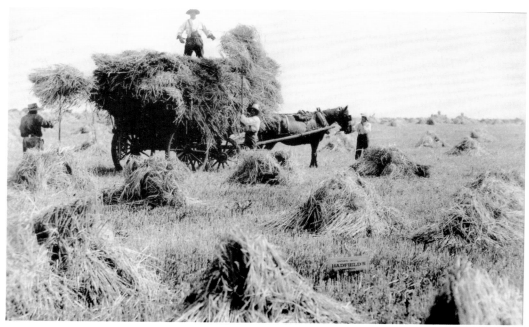

HARVESTING

case of old and experienced ewes I am sure that they understand what is happening to them, as they look quite contented and struggle little—indeed, the shearers say that this is so. The moment that the thing is done—which seems to prove it—they spring up with blithness, and, rushing from the barn, begin to bite hungrily at the grass outside.

It is funny to watch the behaviour of the lambs that are waiting without. One by one they approach the escaped ewe, till at last its own offspring finds her. It takes a lamb a while, however, to convince itself that this strange, naked-looking creature is in truth its dear mamma; indeed, not until it has smelt her all round, and, thankful to find that something is left, knelt down, and with an air of relief helped itself to refreshment, does conviction conquer doubt. The ewes often seem to resent these suspicions; probably their tempers, having been tried to breaking-point, will bear no further strain.

The shearers who make up these travelling gangs are very intelligent men, moving as they do from place to place, seeing much and knowing everybody. Also, as might be expected from the nature of their trade, they are capital gossips. I asked one of them if a certain person who owns a great flock of sheep was a good farmer.

'Oh, he puts it in and takes it out,' answered the old gentleman enigmatically.

'No, partner,' interrupted another man, 'he dew take plenty out for sure, but I never did hear that he put nawthing in,' thereby in a sentence summing up the character which report gives to this tiller of the soil.

The average weight of a ewe's fleece is from four to five pounds; but I believe that the fleeces of hoggets, that is, year-old sheep which have never been shorn before, sometimes weigh as heavy as fifteen pounds.

H. Rider Haggard

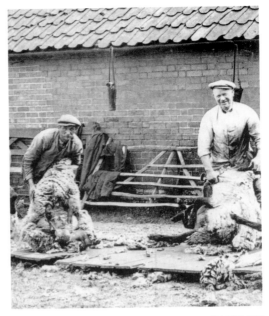

SHEEP SHEARERS AT WORK

IPSWICH: SATURDAY NIGHTS

Ipswich in 1910 was a rough, tough town. One did not venture into the populous parts on a Saturday night because of the drunks who were often to be found lying insensible in the gutter. In 1910 the Lloyd George 'Two acres and a cow' election, so called because of his proposal to create a large system of small holdings, was bitterly contested. The shutters were up in the main streets and the town looked as if it was in a state of siege.

Even in the daytime one could, in the poorer areas of the town, see much drunkenness. I, as a small boy, was privileged to witness a magnificent example of this.

One day, scudding along the street, I was attracted by the shrill noise of shrieks and falsetto curses, and turning the corner I saw on the opposite pavement two women outside a public house. They fought each other clawing, scratching and shrieking like tiger cats. Both had long raven-black hair which tumbled down over their backs and shoulders. Both wore nothing but a thin white nightdress and both were barefooted as if they had just got out of bed. At one moment the stouter of the two dragged her opponent along the pavement by her hair. The next moment the thin one retaliated by tearing away the front of the other's night gown, leaving her heavy breasts and most of her belly exposed.

Edward Ardizzone

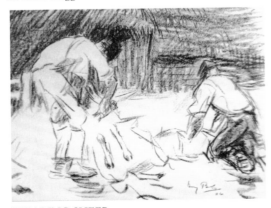

SHEARING SHEEP

IPSWICH DOCKS

'Ipswich at one time was known as the *London Shipyard* because most of the London merchants had their ships built at Ipswich, from the Suffolk forests which were mainly of oak. And the woods round were near and handy: the timber had not so far to be hauled and it could be brought to the shipyards easily. I remember the remains of some of these old yards. There was one shed on the Wherstead Road: I remember as a child seeing this and I wondered whatever the shed was for. Eventually I found out that it was a shed built over one of the launching ways.

'After the sailing ships went out the barges came into their own—the coastal barges. There was quite a number of them built at Ipswich. Some went as far as Dublin; others went up the north. And these were wonderful ships because they were manned by just a man and a boy; and they carried a huge amount of sail in proportion to their size. We had all sorts of sailing ships in, boats from Valparaiso, Sebastopol, Melbourne; and on the jib boom, if you saw a shark's tail, you would know that that ship had come south of *the line*—been below the Equator. This was a sign among the sailors. On the way over they evidently caught a shark; and they would cut off the tail and nail it on the jib boom. There were another type of ship there which among the local people was called *Yonkers*. They were Norwegian, and they got the name from the pumps. Their pump was driven by a small windmill aft of the main mast; and, of course, the pumps were going *yonk, yonk, yonk,* and that originated the name of the *Yonkers*. They came into Ipswich with either timber or ice. Before the people had refrigerators the blocks of ice were loaded there. I've seen tons of ice as large as tables, chopped out of the Norwegian fiords and brought over in these Norwegian ships.

'There was a hospital ship, used for smallpox cases, and the name was rather unusual. It was the *Bokanko*: it was a small barge, about 40 tons, with a deck and rail for an awning. And when there was a serious case of smallpox in the town, they were taken out and the *Bokanko* was towed about a mile down the river and anchored down there. It was an isolation ship left down the river. There was another unusual ship we had up here. We had the old convict ship, *The Success*, which was a lot of interest to visitors. This convict ship was used to transport the criminals from England to Australia. It was, as far as I remember, a barque—three-masted and about 800 tons. The holds were in tiers. There were above five tiers; and it was a most awful ship to go aboard; and to go down and see the cells. The way these prisoners were being confined at that time of day! It was being taken round the country then as an exhibition ship.'

George Ewart Evans

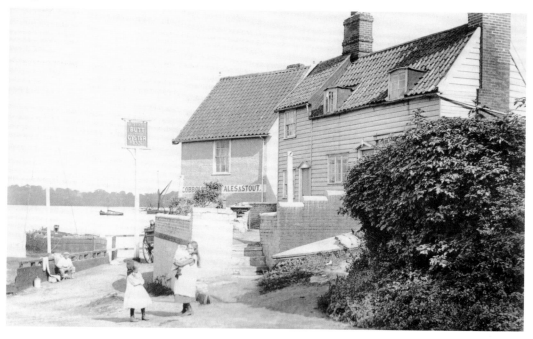

CHELMONDISTON, IPSWICH

PIN MILL

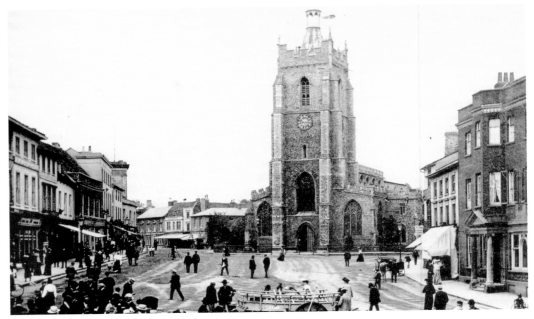

MARKET HILL, SUDBURY

SUDBURY

A PLEA

Monday.

Dear Sir,

I Mr William Beer write this letter to you to ask you if you will kindly oblige me in send me either my certificate of birth or explain to me how i can get it.

I was born in your parish i believe in March 1852 and both my parents died i myself do not remember either so i feel sure you will sympathise with me, people did not seem to trouble about certificates at that time of day but in London if we try to get a situation of any importance certificate of birth has to be produced.

I have a brother and 3 sisters and when father died we two youngest was put in Sudbury Workhouse and when i was twelve years old i was put apprentice for 7 years which i served and got my indentures about a year after that i married and have been 12 years last month so now i reckon i am 33 years next march 2nd that date my older sister say is my birthday.

Will you kindly enquire for me or send it as will return at once the cost.

Believe me Yours
Mr William Beer,
144 Corfield Street,
Waterloo Building,
Bethnal Green Road,
London East.

The Vicar.

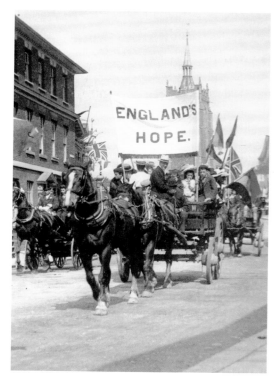

PARADE AT SUDBURY, JULY 1902

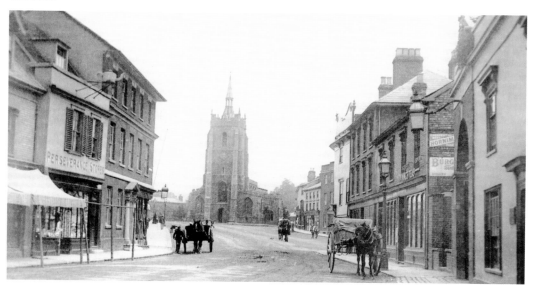

SUDBURY

HARVEST CART

Yow, Jack, bring them 'ere hosses here—
 Get this 'ere waggin out;
I think this weather mean to clear,
 So jest yow look about!
Come, put old jolly to, right quick—
 Now then, hook Di'mon on,
(There chuck yow down that plaguy stick!)
 An' goo an' call old John.

John bo' the 'Cart shod close' we'll try
 (Get yow upon the stack);
I'm sure the whate's by this time dry—
 Bring them 'ere forks here, Jack.
Blarm that 'ere chap! Where is he now?
 Just look yow here, my man,
If yow don't want to have a row,
 Be steady if you can.

Ope that 'ere gate. Wish! Jolly—Wo!
 Cop that 'ere rope up, Sam;
Now I'll get down an' pitch, bo'; so
 Jump up where I am,
Load wide enough, mate—that's the style—

Now hold ye! Di'mond!—Wo-o!
Jack!—that 'ere boy do me that rile—
 Jest mind yow where yow goo!

There goo a rabbit! Boxer, hi!—
 She's sure to get to grownd,
Hold ye! Now then bo', jest yow try
 To turn them nicely round.
Don't knock them shoves down! Blarm the boy!—
 You'll be in that 'ere haw!
That feller do me so annoy;
 But he don't care a straw!

How goo the time? I kind o' think
 Our fourses should be here,
Chaps, don't yow fare to want some drink?—
 There's Sue with the old beer.
The rain have cleared right slap away,
 An' if it hold out bright,
Let's work right hard, lads (what d'ye say?)
 An' clear this feld to night!

'Quill'

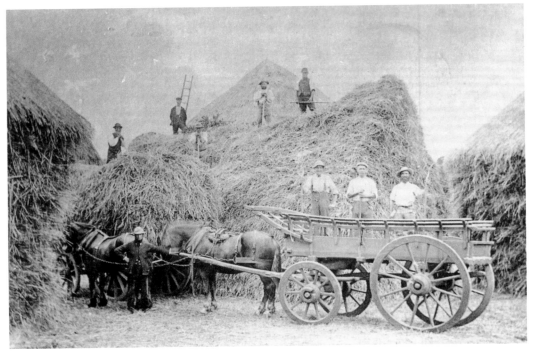

HARVESTING AT WALDRINGFIELD

CATLIN'S DUKE

Take him all in all he was the most perfect horse that I can call to mind. From a foal to his decrepit old age he was a great favourite with all who could forget or forgive the alloy in his composition. He first came out as a two-years-old when he at once made his mark, although he then looked to some, rather too 'punchy', but from that time he grew in length and certainly became the most popular horse of his day; and if his work be measured by his produce he exceeds all Suffolk horses in the number of winners at shows left by him, both colts and fillies. His procreative powers were extraordinary, and I had it on the authority of his leader, Charles Row, a man of undoubted integrity, that one season he booked eleven score mares to him, and it is well known that no horse left a greater percentage of mares in foal. In colour he was a good chestnut, 16½h.—fairly wide; his forelegs slightly crooked, very bent in at his knees, which caused him to 'dish' his feet out a bit in his action, which lost him the prize at Norwich. His head was a little too wide (showing the alloy); the width of his back caused by the great development of the muscles was remarkable. I remember seeing him at Woodbridge, and hearing the late Mr Webber exclaim that the hollow there formed would 'hold a basin of soup'. 'A basin,' exclaimed Mr Flatt, 'why it would hold a pail full.' His temper and constitution were all that could be wished; the former all his produce inherited, temperate in work, and a child could manage them; while no common day's work tired them, they always left off work with a good appetite for any kind of food. A few years before his death he had an attack of fever in his feet, otherwise he died in a good old age—perfectly sound—having I suppose left more recorded descendants than any other horse.

M. Biddell, 1880

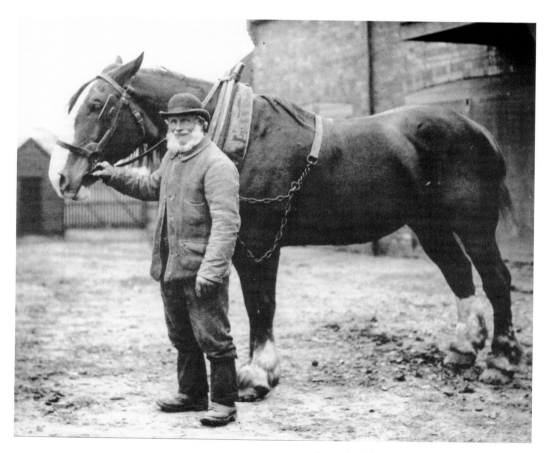

HORSEMAN, MELTON, WOODBRIDGE

OWD CHARLIE A'LARNING

We wonderful laughed
 At ow'd partner Charlie,
As we set on the shaft
 Of a wagon o' barley.
 We'd had fourses
 Unyooked the hosses,
 And stopped worruk right 'arly,
 When, behow'd ye, come Charlie!
We wonderful laughed!

We wonderful smiled,
 He was then a-tarnin'
The corner o' the fi'ld,
 Says he, 'I'M a-larnin'
 This here new invention—'
 That worn't his intention,
But, behow'd ye, he sorter
Downed, like a tippen-a-torter,
Inter a deek full o' water,
 Oover goo Charlie!
We wonderful smiled.

He was wonderful wild
 When he slubbed out and shivered,
His dopper was sp'iled,
 And with muck he was kiwered.
 But he doon't trouble!
 Up he mount like a bubble
Gooin' wiggly-warly, wiggly-warly!
'Up again!' say ow'd Charlie;
And, trewly to tarl ye,
 He bumped inter the shaft
 As if he was daft,
 And his wheels come in halft—
We wonderful laughed!

And I'd give an arternoon's
 Wages, and my ow'd bewts,
For one o' them cameroons
 (For takin' o' snap-shewts)
 To ha' took his foorygraft!
 Yow'd ha' wonderful laughed!

F. J. Gillett

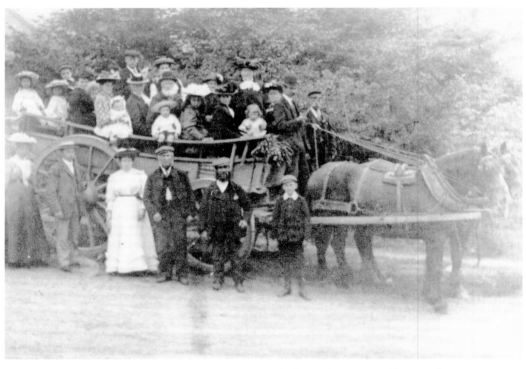

AFTER HARVEST OUTING, WALDRINGFIELD

Edward Moor, a native of Suffolk, published *Suffolk Words and Phrases* in 1823, which he called an attempt to collect the lingual localisms of Suffolk; and over two and a half thousand words were collected. The frequency of Suffolk usage which appear in Shakespeare's works is of especial interest and this is one of the many things that impressed Adrian Bell a century later when he went as an apprentice on a Suffolk farm:

> I went out into the field with them [the farm workers], hoeing. But they took little notice of me and just went on talking one to another, talking all the time while they singled the young seedlings with their bright hoes. . . But I listened to them and I was amazed. Here they were speaking in a language I knew of but had not heard, nor ever imagined it could still be heard. I'd just come from four years in a public school; but no one there had told me that the language that was the real glory of English literature was still being used in the field by unlettered men like these.

He had to go horse-hoeing, leading a horse carefully between the rows of young plants and a farmworker told him: 'You lead that mare as slowly as ever foot can fall.' The phrase 'as softly as foot can fall' occurs in *As You Like It*, but it is unlikely that that old farmworker had ever even heard of Shakespeare. And Adrian Bell remarked, 'It was a privilege to listen to these men.'

Many of the words in Moor's collection are not heard today simply because there is no longer any need to use them; for instance the many words used in the days of horses and handwork on the farm were spoken daily only fifty years ago. It is interesting to see that some words—cratch is one—that Moor said he believed were obsolete survived to at least mid-twentieth century.

This glossary is a selection taken from Moor's book but reference has also been made to *The Suffolk Dialect* by A.O.D. Claxton which was first published in 1954. Other written sources have been the books of Adrian Bell and George Ewart Evans. Like Adrian Bell, I think it a privilege to listen to the Suffolk dialect but over the last thirty years it has become an increasingly rare privilege.

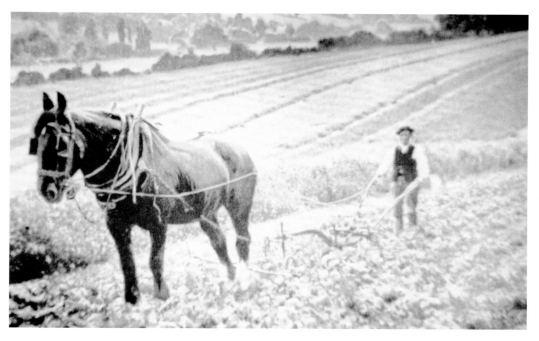

HORSE HOEING ROOTS

AADLE to prosper or flourish

AATA after

ACRE-SPIRE the sprouting of barley

AFEARD afraid

A-GAH the ague

AHIND behind

A-HUH awry

ALL ON THE DRAG all behind time

ANKLE JACKS shoes reaching below ankles

AINT to anoint (as for the itch)

ALAWK alack, alas

ALEGAR vinegar made from beer

ALE-STALL stool for casks

ALP bullfinch

ANOINT to beat

ANTRUMS affected airs, insolence

APIECES to pieces

ARRAWIGGLE ear-wig

ARSE UPPARDS upside down

ARSY VARSEY topsy-turvey

ARTERNUNE FARMER lazy farmer

ATWIN between

AVEL barley awns

AVELLONG workman approaching side of field not parallel with their work

BABBING catching eels or crabs with bait on line without hook

BACK-STRIKING second ploughing turning earth back

BACK-US back kitchen

BACK-US BOY odd job boy

BADGET the badger

BAFFLED growing corn or grass knocked about by wind (or cattle, etc.)

BAIL bow attached to scythe

BANG poor and hard Suffolk cheese

BARE-EM load of wood carried on back

BARGAIN load on a wagon

BARKSELE bark harvest

BARLEY BIRD nightingale

BARM SKIN fisherman's oilskin apron

BARNABEE ladybird

BARNACLES spectacles

BARNED housed in barn

BARRA-PIG smallest pig in litter

BARLEYSEL barley harvest

BATLINS tree lopping for firewood, hedging or hurdle making

BAVENS brushwood

BAWDA to abuse grossly

BAWK ridge in ploughing or contrivance for holding cow's head

BAWLEY BOAT large yawl-like boat

BEAT (or BETE) to repair nets

BEASTERS women or girls who repair nets

BEAVERTEEN JACKET close fitting twill jacket

BEEVERS afternoon food in field

BEGONE worn, old, decaved

BEMIRE admire

BENTLES land by coast overgrown with coarse grass

BESTOW to put away

BEZZLE to drink greedily

BIBBLE to tipple

BIG FARE UN self important man

BIGGEN to increase in size

BILLY WITCH cockchafer

BINE-BINE bye and bye

BLACK HOGS darkness

BLACK MEAT bacon

BLOCKARDS herring fry

BLOWN HERRINGS herrings when sold partly cured

BOB-BEAR A B. be brisk

BOOT-MAKERS HOLIDAY Monday

BOP, familiar address, friend

BOTSY rabbit

BOUD weevil

BOUT HAMMER blacksmith's sledge

BOWNE to wind-dry sprats

BRACKLE ripe corn

BRUSTLE to bustle about

BUCK body of wagon, tumbril or windmill

BUFFLED ripe corn not standing

BUFFLE-HEADED confused or in difficulties

BULL'S NOON midnight

BULLY the man on stack who received sheaves pitched from below

BULLY HOLE place where bully stands

BUMBY quagmire, contents of privy

BUTTREE blacksmith's tool

BUSSEN belly, ruptured

BUTTRICE tool used by farriers

BUZZHAWK nightjar

CABOBBLED confused, puzzled

CADDAW jackdaw

CADE measure of herrings or sprats

CAMP a game played in Suffolk

CANCH slice cut out of hayrick

CAPPER hard crust on harrowed land

CARNYING wheedling, coaxing, flattering

CAST tinge or colour (of a field)

CAT ferret

CHARLEY toad

CHUBBY angry, threatening

CHICE small quantity, a taste

CIS a poor attempt

CLIPPING sheep shearing

CLAG-WHEAT bearded wheat

CLUNG shrunk, dried shrivelled (of apples, turnips, etc.)

CLUNK to whet a blade on a stone

COB waste product from clover threshing

COB ROE hard roe of fish

CODD to grumble

COLDER husks on short pieces of straw

COME BACKS guinea fowl

COOMB four bushels (of corn)

COPPEROZE common red field poppy

CRAG the masses of marine shells

CRATCH a manger

CRINKLY CRANKLY winding in and out of a c.g. wall

CRIPPLES supports for wagon 'rafe'

CUMATHER an order to horse to turn left

CUMFOOZLED intoxicated

CRUDBARRA wheelbarrow

DAFFY mid-day meal

DAG dew (especially of morning dew)

DEW-DRINK first allowance of beer to harvesters before work begins

DICKEY donkey

DIMSY DAY dull day

DO if not, if so

DOCKEY mid-morning food in the field

DOLMAN snail

DRAGGLE-TAILED female untidy about the petticoats

DRIV drove

DUFTIN horse's bridle

DUKES sparrows

DUN BILLY crow

DUNK house sparrow

DUNT blow (on neck or head)

DUST dare

EARNEST sum given to servant when hired

EARTH one ploughing

ENOW enough

FARE to feel, seem

FIERCE lively, fit, frolicsome
FILLA shaft horse
FLINCHERS fisherman's oilskin leggings
FOUR-A-LETE junction of four roads
FOWERSES afternoon meal in fields
FROLIC celebration, festival, harvest supper
FUDDA farther

GATTIKIN clumsy
GAYS pictures, illustrations
GEW went
GIBBLE GABBLE idle talk
GIT to gain
GLAZEWORM glow-worm
GLENT gleaned
GOINGS rights of grazing on common
GOTCH large big-bellied jug
GO TO i.e. a pocket knife don't 'go to' open
GREEZE to keep folding cattle or sheep
GRUTCH grudge

HARNSEY heron ('I know a hawk from a handsaw'. *Hamlet*)
HAKE indented iron head of plough
HANK the fastening or latch of a gate
HANSEL first wearing of new clothes
HASH harsh
HASP (see hank)
HAYSEL hay harvest
HEELER worthless fellow
HEFTY of weather when rough
HE'T have it
HEW heed
HEWD held
HIGHLOWS high shoes or low boots
HIGLER itinerant dealer in small wares
HIRE to rent farm or house
HOBBLE place for hogs
HOBBLY rough, uneven
HOBBLY DOBBLES mole hills
HOBBY pony
HOBBY LANTERN will o' the wisp
HOLLY wholly, completely
HOLP helped
HOLZER old name for Halesworth
HONKY DONKS hob-nailed boots
HOPNETOT frog
HORN bow of a scythe

HORN-PIE peewit
HOUNCE ornament across shoulders of horses in a team
HOUZEN houses
HOWD hold
HOY 'gee up' to horse
HUDDERIN big awkward youth
HULVER holly
HUMMER gentle murmuring of pleasure by horse
HUTCH corn bin
HUTE mood

ILE oil
IMITATE to attempt, try
IRISHES stubble
ISAAC AND ASH scythe

JACK swelling on a horse's back
JACOBITES thistles
JAHNEY a day's work
JAMMERING shouting
JIFFLE to fidget, bustle to no set purpose
JIGGET mildly to jolt
JIP to gut herrings
JOBANOWL thick-headed fellow
JOLLACKS appellation applied to clergyman
JOSS command to horse or cow 'to move over'
JOUNCE shock of carriage sinking into deep ruts
JOURNEY day's work at ploughing
JOWLIES young herring
JUB pace of horse between walk and trot
JULK hard blow

KEEPING ROOM living room
KIDDIER man who buys fowls, eggs from farms and hawks them around
KIDDLE to fondle
KNAPPISH spiteful, snarling

LACE to beat, punish
LACED MUTTON a loose woman
LARABAG lazy person
LARGESSE given to workers on completion of harvest
LAVROCK the lark
LEASTY dull wet weather
LEECE lice
LIB container for holding seed corn
LIKELY pregnant, also goodlooking

MADGE magpie

MARDLE to gossip

MAWTHER a girl

MEAL one milking

MEECE or meezen mice

MEETINER Nonconformist

MEW past tense of 'to mow'

MINE my house, my farm

MORFEYDITE (abb. Hermaphrodite) tumbril with attachments converted into harvest wagon

MUDDLED heated and tired from work; in a bit of a muddle; in great or lesser trouble

MALLYGRUBS fancied ailments, ill humour

MUMBLE-BRED cross-bred

MUMP to beg

MUNJIN a good feed

MURE HEARTED tender hearted

MUSSY mercy

NABBLE nibble

NANCY small lobster

NANNICK to play the fool

NAPPER head

NATIVE birthplace

NAWN nothing

NEAT cattle

NEEZEN plural of nest

NEIGHBOUR used as verb 'She don't fare to neighbour well'

NATS-EYES first longshore herring

NETTUS cowhouse (neat-house)

NEWIED exhausted

NEWS'D published in newspaper

NICKLED of corn beaten down or too weak to stand

NIDGETTIN attending to woman in labour

NIFFLIN whining, unhappy

NIGGER the neighing of horse

NIGGLE mincing gait

NIGH NOR BY near

NINE-HOLES a game

NINNY simpleton

NIVVA never

NO ART 'what-do-you-call-it'

NO FINNY not likely

NOGGIN building (Moot Hall, Aldeburgh, specimen of Noggin)

NO MATTER in poor health

NONNAK irregular work

NONNAKIN idling

NONNAKS jibes, fears

NOONCE purposely

NOONINS mid-day meal

NOTTAMY a skeleton

NOWANTON now and then

NOWL the head

NUB back part of the neck

NUBBLE nape of the neck, to walk with head down

NUMB CHANCE stupid person

NUMPOST deafness

NUNNY WATCH not well

NUT not

NJTTERY STUBS clumbs of hazel

ONGAIN unsteady, unpromising

ONMOST almost

ONPOSSIBLE impossible

ONSENSED senseless (from a blow, etc.)

ON THE DRAG behind time

ORATION public talk, noisy rumour

ORDINARY poor quality

ORTS fragments of turnips left by sheep

ONTOWARD unsteady

OUT AXED marriage banns

OUT A THE WAH out of joint

OUT OF HEART worn out (applied to land)

OUT O' BED mistaken

OUT-HAWL to scour or clean ditch or pond

OVEN BIRD long-tailed tit

OVER DAY stale

OVERGIVE to exude, ferment

OVERPEER projecting

OVERWART to plough or cultivate at a right angle to previous ploughing

OWN HIN influenza

OWD SALLY (or SARAH) a hare

OWLEN to pry

PACK GATE footpath gate

PACK MEDDA meadow with footpath

PAH-YARD straw vard

PAIGLE cowslip

PALARVARINS excuses

PAMPLE to trample

PANE portion of measured work set

PARSAYVANCE wisdom

PEAKIN sickly

PEASON peas

PED basket

PEG a blow or thump

PEND pressure, strain, force, stress
PENNY WAGTAIL water wagtail
PENSEY complaining, dull, sickly, thoughtful
PENTIG pent-house or lean-to
PERKY WIND a sudden whistling wind
PIGHTLE a small meadow
PIM very weak beer
PINGLE to eat very little
POD the belly
PODDY corpulent
POLLIWIGGLE tadpole
POPPLE to tumble about
POTTENS crutches
PROG a spike, goad
PRUDENT seaworthy
PUMMELTREE whipple tree
PURDY proud, ostentatious, surly
PUTTER to nag, talk to oneself

QUACKLE to suffocate, choke
QUAG soft, shaking, wet land
QUAIL wet, marshy land
QUEECH untilled, rough, bushy corner of field
QUEZZEN to smother or choke

RABS big clumsy feet
RACKS cart wheel ruts
RAFUS framework to enlarge wagon
RAFTY windy, wet, cold weather
RAILIN fishing for mackerel
RANNY shrewmouse
REDDOWLD red and white cow
RESH fresh, recent
REWE said of manure that is fresh
RIND lean, scraggy woman
RINGE a row (of plants)
RISP green stalks of climbing plants
RIST ascent or swelling in land, a road
RIVE to split
ROAR to salt herrings and turn them over and over
ROARER wooden basket for carrying salted herrings
ROARING BOYSA men who salted herrings
ROARING SHOVEL used for salting herrings
ROWEN aftermath, second crop of hay
ROKY misty, especially sea mist
RUDLE warm beer with gin, sugar and a slice of lemon

SAPSCULL silly, shallow fellow

SAXMUNDHAM CALICO flimsy cotton

SCANDAL-BROTH tea

SCORE a cutting down a declivity

SCUD to shake fish out of a net

SCUPIT spade

SHALE the mesh of a net

SHIP sheep

SHEW past tense of 'to show'

SHIM white mark on forehead of horse

SHOCKS stooks of corn

SHOOF sheaf of corn

SHRUFF dry wood, hedge trimmings

SHRUCK past tense of 'to shriek'

SHUCK to rub out ripe corn in the hands

SLIGHT wear on boots, clothes, ropes

SLOD past tense of 'to slide'

SLOE HATCHING TIME 'blackthorn winter'

SLUB mud and mire

SLUD slush

SMALLEN to make smaller

SMIGS small fry of herrings

SMUR small rain

SNAPSES meal taken in field early morning

SNAP your eye to wink

SNEAD handle of scythe

SNEESTY churlish, snappy

SNEW snowed

SNOTTING GOBBLES yew berries

SOLIN a thrashing

SOLOMON GRUNDY pickled herrings

SORREL chestnut coloured

SOSH crooked, slanting

SOWJA a red herring

SPARLINS sprats

SPINK chaffinch

SPIRKET wooden peg to hang things on, such as harness, clothes

SPONG narrow strip of land

SPUFFLER boastful or bustling man

SPURK brisk, smart

STAITHE landing place, wharf, quay

STAM to astonish, amaze

STETCH land between two furrows

STITHE hot, oppressive

STUVA/STOVER clover hay

SUMMERLAND fallow land

SUNKET sickly child

SWALE pump handle
SWACKEN large, thumping, jolly
SWINGEL the part of a flail which beats corn
SWING-PLOUGH plough without wheel
SWOUNDED swooned

TANTICKLE stickleback
THAT DO it does
THEW thawed
THROSH thresh
TRAVVIS open shed in which horses are shod

UNGAIN not handy
USEN in use

WEESH/WHISH command to horse to turn right
WELLUM culvert
WHIPPLETREE bar to which traces of horses are fixed
WUNNAFUL Waldringtield

YARMOUTH CAPON red herring

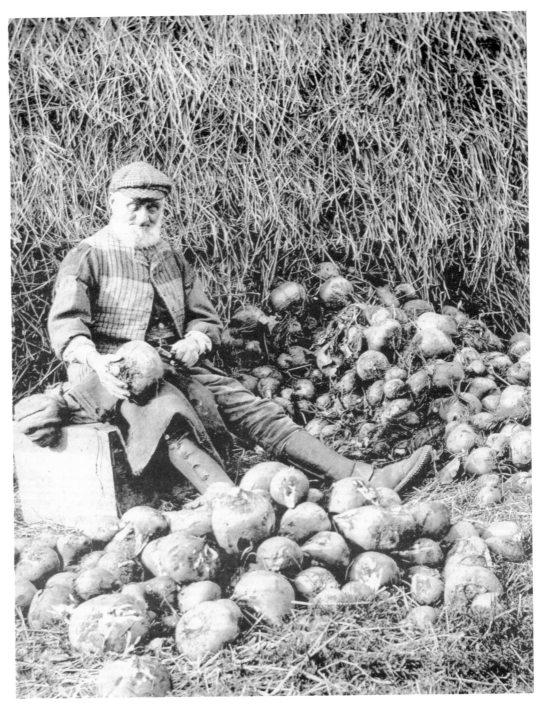

CLEANING ROOTS AT WALDRINGFIELD

SOURCES & PHOTOGRAPHIC DETAILS

ACKNOWLEDGEMENTS

For the loan of photographs I am extremely grateful to: D. Banthorpe, Bungay Museum, R. Collett, N. Edgar, S. Evans, J. French, Haverhill Historical Society, D. Kindred, Leiston Longshop Museum, M. Morris, D. Moyse, D. C. Shotton, Suffolk Record Office, The Waller Collection.

TEXT

All the pages listed below relate to pages in this book and not to the page numbers of the source books.

The main sources for descriptive text are Henry Rider Haggard, James Cornish and George Ewart Evans.

Henry Rider Haggard: *A Farmer's Year* (Longmans); *Rural England*, Vol 2 (Longmans); James Cornish: *Reminiscences* (Country Life); George Ewart Evans: *Ask the Fellows Who Cut the Hay* (Faber); *The Days We Have Seen* (Faber); *Where Beards Wag All* (Faber); Other works used are: Dorothy Thompson, *Sophia's Son* (Dalton); George C. Carter, *Looming Lights* (Constable); Edward Ardizzone, *The Young Ardizzone* (Studio Vista); John Glyde, *Suffolk in the Nineteenth Century*; Charles Harper, *The Norwich Road*; Peter Cherry and Trevor Westgate, *The Roaring Boys*; E.R. Cooper, *Story of Southwold*; Francis Hindes Groom, *The Suffolk Friends*; W.G. Clarke, *Norfolk and Suffolk*; M. Biddell, *Suffolk Stud Book*; Henry James (On Dunwich); 'Quill' poem; E.J. Gillett poem.

Newspapers and magazines include: *Essex Chronicle*; *Suffolk Chronicle*; *Bury Free Press*; *The Bury Post*; *South West Suffolk Echo*; *East Anglian Daily Times*; *Illustrated Police News*; *Quarterly Review*; *East Anglian Magazine*; *Haverhill History Society Magazine*; *Cracker*.

Material in manuscript includes: A. Aldis, letter; Philip Thompson, diary; Trevor Westgate; T. H. Waller; William Beer, letter; Farm Tenancy Agreement.